SECRET
RIPON

David Winpenny

AMBERLEY

First published 2018

Amberley Publishing
The Hill, Stroud
Gloucestershire, GL5 4EP

www.amberley-books.com

Copyright © David Winpenny, 2018

The right of David Winpenny to be identified as the
Author of this work has been asserted in accordance
with the Copyrights, Designs and Patents Act 1988.

ISBN 978 1 4456 7216 8 (print)
ISBN 978 1 4456 7217 5 (ebook)

British Library Cataloguing in Publication Data.
A catalogue record for this book is available from the
British Library.

Origination by Amberley Publishing.
Printed in Great Britain.

Contents

Introduction 4

1 The Ground Beneath Our Feet 5

2 Cathedral Curiosities 14

3 Square Roots 32

4 Temperance, Drama and Bathing 45

5 Trying Out the Spa 53

6 Dissenters and Paupers 64

7 Saints and Woodbines 73

8 By the Waters 88

Acknowledgements 96

Introduction

Ripon is an enigma. A market town that is one of England's smallest cities. A cathedral that for most of its history was known as the Minster. One of the army's largest camps during the First World War. A pattern of tightly packed medieval streets and unexpected open spaces. A place once famed for its woollen cloth, long before the mill towns of West Yorkshire and beyond took away the trade, and then for its spurs and its saddle-tree makers.

Is Ripon well known? Yes, for its races and for occasionally hitting the headlines when a hole appears in the landscape and threatens property. Yes, too, as a signpost to the attractions that lie around it. On the doorstep is a World Heritage Site, Studley Royal and Fountains Abbey. With its monastic ruins and early eighteenth-century water garden, it is one of the National Trust's top sites, with more than 420,000 visitors in 2017. Nearby, too, is Newby Hall, the elegant country house with attractions that include a miniature steam railway, an adventure playground, doll's houses and teddy bears. Just north of the city are the thrilling rides of Lightwater Valley Theme Park. Visitors to all these attractions know that they are near Ripon, but only a small percentage of them will come to the city.

Riponians would like to change this. We know that the city is full of interest – not just the cathedral, which is our major magnet for visitors, and the racecourse, which enlivens the city on race days, but our three Law and Order Museums, our historic Market Square, our traditions, especially that of the Hornblower, and the links with Lewis Carroll. You will find more about all these in the chapters that follow, and we hope visitors will find that, as Ripon reveals some of its secrets, they will discover the real Ripon, the Ripon that its inhabitants have valued for more than 1,300 years.

This is not a history of the city, though history will inevitably be part of the narrative. Nor is it a guidebook, though it is broadly arranged into a series of walks around the streets. Much of it is taken up with the buildings of the city, the structures that form its fabric and mirror its past. In general it restricts its scope to the ancient heart of the city. It also introduces some the characters that have been native to Ripon or made their home in it – scientists and eccentrics, writers and poets, clergy and actors, and even a murderer.

To help explore, Ripon Civic Society, founded in 1968, has provided almost forty informative plaques – green rather than the traditional blue. It has also harnessed technology to help further – download the software from gamar.com, then point your phone or tablet at a plaque to find photographs and spoken information. The society has also been conserving, with the help of a Heritage Lottery Fund grant and the assistance of North Yorkshire County Council, more than 8,000 old photographs of Ripon. Some are used in this book and many more are available online at riponreviewed.org.

So, welcome to *Secret Ripon*. If you live in the city, much may be known to you already, but there may be some surprises. If you are a visitor, enjoy discovering the lie of the land in this ancient city, and unravelling the enigma that is Ripon.

1. The Ground Beneath Our Feet

It's 19 June 1834 and we're standing on the edge of a pit, looking down. The shaft is deep – at least 50 feet (15 metres) – and punches its way through the red sandstone to a shadowy, rubble-and-vegetation-strewn base. Yesterday, there was no pit; this chasm opened suddenly.

The local newspaper reported that 'Ripon and the whole neighbourhood was shaken by a tremendous explosion, occasioned by a convulsion of nature, about a mile from the town, by which the earth had been affected to such a degree as to leave a fissure nearly twenty yards in width, and twenty-four in depth.' While a local diarist noted, probably more accurately, that 'a large quantity of earth sunk on the hill leading to Hutton, across Sharow Ox Close, leaving a chasm twenty-two yards deep and twelve or fourteen yards wide'.

Two sheep fell into the hole and were, with difficulty, rescued with ropes. Now fenced off on the edge of farmland, the 1834 sinkhole is still visible; trees grow around the top – some of them teeter on the edge of the hole – and the grass grows up to the rim. There are other, similar holes nearby.

Forward to 10 November 2016. At around 10.30 p.m., two gardens behind houses in Magdalen's Road vanished into a sinkhole, which eventually stretched 65 feet (20 metres) wide and was at least 30 feet (9 metres) deep. It disrupted the sewerage system and made neighbouring houses uninhabitable for many months until the hole was filled and the services were restored. In February 2017 another sinkhole appeared beside Ripon Leisure Centre, near the site where a new swimming pool is planned.

Sinkholes just north of Ripon, now surrounded by trees.

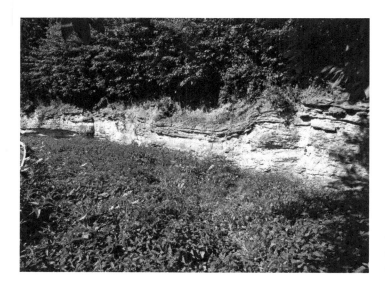

Unique remains of the tropical Zechstein Sea at Quarry Moor.

Sinkholes are Ripon's most worrying secret. For millennia they have regularly pockmarked the landscape in which Ripon sits. Areas mostly to the north-east of the city centre – though with others scattered to the west and south – are prone to sudden collapse.

Why is Ripon prone to so many sinkholes? To understand, we need to go back 250 million years to a time when what we now know as Britain was on the shores of a primal ocean, known today as the Zechstein Sea. This was just north of the equator. On this littoral land, where the warm sea lapped the arid sun-baked shore, large mats of algae formed. Over millennia the water evaporated, turning the algal mats into gypsum. You can see remains of the Zechstein seashore, unique in Britain, in the nature reserve of Quarry Moor, to the south of Ripon, just by the Harrogate Road roundabout at the end of the bypass.

It's gypsum that has really shaped Ripon and caused its sinkholes. With continental drift, the land moved north to its current position – and the gypsum came, too. It is mixed with the Permian limestone and marls of this part of North Yorkshire. Unlike most stones, though, gypsum is very vulnerable to being water-soluble. Over the centuries the gypsum pockets dissolve, leaving a series of voids and caverns beneath the surface. Eventually the land above may suddenly collapse into the cavity beneath; into these sudden sinkholes buildings, gardens and agricultural land fall.

If you look at the map of how Ripon has developed, the layout of the built-up area may look illogical; there are large portions where no development has taken place – some of them close to the city centre. These are the places where gypsum lies beneath the surface, though it's not always possible to be sure where the next sinkhole might appear.

When buildings are severely affected by gypsum collapse they are usually cleared away – though a new house that collapsed in 1997 on Ure Bank, just across the River Ure, has been left to crumble back into the land beneath an ever-increasing burden of vegetation. Others, less drastically, are patched up and display the leaning windowsills

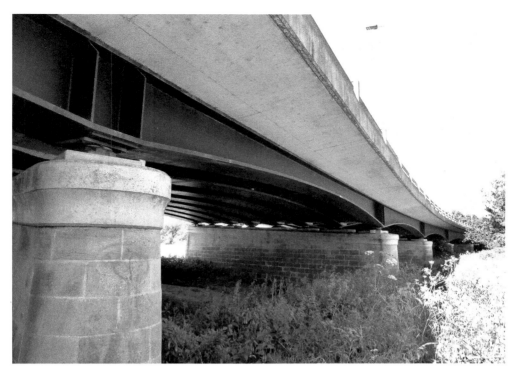

Ripon's bypass bridge, engineered to withstand sinkholes.

and doorframes that suggest subsidence. A walk down some Ripon streets – try, for example, Princess Road, eastward from the Clock Tower – will provide examples.

The underlying gypsum affected the building of Ripon's bypass in the 1990s. The Duchess of Kent Bridge, at the bypass's northern end, takes the carriageway across the River Ure and through the gypsum area. The danger of a sinkhole opening below one of the supporting piers of the bridge was obvious. So the foundations below the piers are extended a considerable distance to each side, and the bridge deck has been strengthened to ensure that even if one of the piers collapses into a subsidence hollow, the deck will remain stable (though no longer useable) and any vehicles will not be precipitated into the river. The piers are also monitored electronically, and the approaches to the bridge are specially strengthened with polymer-based geogrid material.

Gypsum is an enduring problem for Ripon, though it is a versatile mineral, used for plaster and plasterboard, as a fertiliser and in the food and medical industries. As alabaster it can be readily carved, and in medieval monasteries it was mixed with powdered white lead to make gesso, applied to manuscripts before illuminating ornamental letters with colours or gold. Ripon's gypsum may have provided a source for the monks of nearby Fountains Abbey, for example.

Long before the Middle Ages there had been another local use for gypsum. Ripon lies in the lower Ure Valley, one of the most archeologically rich areas of Britain, described by Historic England as 'the most important ancient site between Stonehenge and the Orkney

Islands'. From Catterick to Boroughbridge a series of henges was constructed in the late Neolithic and Early Bronze ages. The most unusual are the Thornborough Henges, a row of three circular banks and ditches, dating from between 3500 and 2500 BC, whose layout resembles the stars of Orion's Belt. The central henge was constructed in part over an earlier earthwork, the Thornborough Cursus, a round-ended ceremonial avenue almost a mile long, bounded by ditches.

The siting of the Thornborough Henges, between the rivers Ure and Swale, was also near the gypsum belts. Excavation has shown that the henge builders dug pits to extract the gypsum, which was then used to whiten the banks they had constructed. The three henges (and probably nearby ones, including a now-vanished one at Nunwick immediately north of Ripon) would have shone out brilliantly in the prehistoric landscape. This area is usually interpreted as a 'sacred' or 'ritual' landscape, though after more than four millennia that can only be speculation.

DID YOU KNOW?
The name of the River Skell comes from an Old East Norse word 'skjallr'. It means 'resounding' – probably because of the noise it made as it rushed along its course.

Romans and Monks

The tracks and paths that our prehistoric ancestors made and used in the area have long since vanished, unless some of our roads and byways follow them without our knowing. Still traceable nearby, however, are the routes that the Romans made after their conquest of Britain. Located 4 miles east of Ripon was the Roman road that later became known as Dere Street; the A1(M) now follows some of its route.

Despite this proximity of passing legionaries and all the traffic that a good road will always generate, the Ripon area seems not to have had a particular attraction for settlers. Remains of Roman occupation are scanty; a few pieces of tile, pottery and glass from in and around North Street and some coins from Skellbank. There's an unverified tradition that there was a Roman ford across the Ure, a stone's throw downstream of the current North Bridge.

In the surrounding villages there is more indication of Roman settlement, with archaeological evidence turning up in the nearby villages of Nutwith, Sutton, Well, North Stainley and Grewelthorpe. A few miles south-east there was an important Roman town at Aldborough. The Romans knew it as Isurium Brigantum, and it was the administrative centre for keeping tabs on the important local British tribe, the Brigantes.

After the departure of the Romans in the fifth century AD, little is heard of the area until the middle of the seventh century, though a century before that members of the Hrype tribe settled in the area where the River Skell joins the larger Ure, which was fordable nearby. It's from the Hrype that we get the name of the settlement; at the start of the eighth century chroniclers called it 'Inhrypis' or 'Inrhypum', which eventually was

Probable site of the Roman
ford over the River Ure.

transformed into 'Ripon'. Other place names associated with the widespread Hrype tribe include Ribchester in Lancashire and Repton in Derbyshire.

Around the year AD 655 Prince Alhfrith, son of King Oswy of Northumbria, gave land in Ripon to the abbot Eata of Melrose, who established a new monastery on a site to the north-east of the present cathedral – a Ripon Civic Society plaque is located near the place. With Eata came a young monk called Cuthbert, later St Cuthbert, Bishop of Lindisfarne, who acted as the monastery's guest master.

Not long after Cuthbert was in Ripon, Alhfrith adopted the Roman style of worship instead of the Celtic. Eata and his monks, who seemed to have rejected the change, withdrew from the Ripon monastery – or were turned out. Bede wrote that 'All the ways of this world are as fickle and unstable as a sudden storm at sea. Eata and all the rest were thrown out of Ripon and the monastery they had built was given over to other monks.' Alhfrith gave the site to Wilfrid, who rebuilt the monastery on a nearby site.

Adjacent to the Celtic monastery was a burial ground, used from the sixth to the ninth centuries, on a hill formed by glacial residues, deposited after the ending of the last Ice Age, when meltwater from Wensleydale rushed down what is now the valley of the River Skell. This mound is now called Ailcey Hill, but was previously known by a variety of names, including as Ailey, Hillshaw and Ellshaw Hill. It was probably used as a burial place by both the Celtic foundation and by Wilfrid's monastery. A modern Celtic-shaped cross in memory of St Cuthbert was erected outside Ripon Cathedral Primary School, next to Ailcey Hill, in 2004.

Wilfrid is one of the major figures in Ripon's history. A dynamic and forthright character, his brusque and uncompromising manner undoubtedly made him plenty of enemies. His chief claim to fame was his passionate promulgation of the rules and canons of the Roman Church; as well as being a monk in the Celtic monastery on Lindisfarne, he had spent time in Rome itself. At the Synod of Whitby in AD 664, he persuaded the assembled nobles and clerics to adopt the Roman way, especially for the calculation of the day on which Easter should fall.

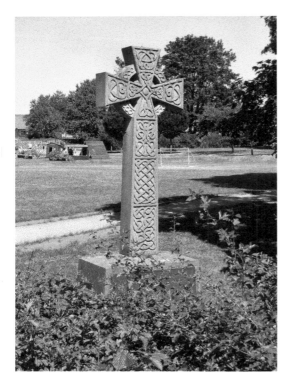
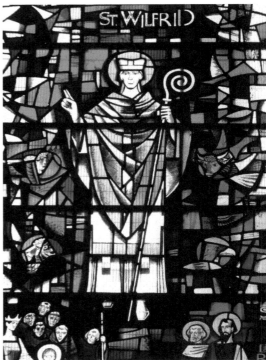

Above left: This modern cross commemorates St Cuthbert's time in Ripon.

Above right: St Wilfrid, from a stained-glass window in Ripon Cathedral.

At various times abbot of both the Ripon monastery and its sister at Hexham, Bishop of Northumbria and Bishop of York, Wilfrid was banished several times and reinstated in his posts. Yet despite all the political and ecclesiastical intrigue that surrounded and preoccupied him, Wilfrid managed to build a great stone church for his Ripon monastery. His first biographer, Eddius Stephanus, writing immediately after Wilfrid's death in around 710, describes how 'he started and completed from foundation to roofbeam a church built of dressed stone, supported with columns and complete with side aisles'.

DID YOU KNOW?
Ripon has been visited by an angel. The Venerable Bede's *Life of Cuthbert* tells a story of the saint welcoming a young man to the monastery. Cuthbert washed his hands and his feet; the youth said he had to leave quickly, but Cuthbert insisted he stay and went to fetch freshly baked bread for him. On his return, the young man had vanished. Though there was snow on the ground, there were no footprints. Cuthbert realised he'd been entertaining an angel.

Wilfrid's Crypt

Astonishingly, the crypt of Wilfrid's church still survives beneath the later cathedral – the other famous underground place of Ripon. It is claimed as the oldest place of Christian worship on Britain still in use. Descending from the nave of the later cathedral built above it, and down a winding passage, you reach a vaulted, intimate space, said to have been modelled on the tomb in which Jesus was laid.

The curved vault is remarkable. It has stood for more than 1,300 years and its pinkish plaster is as hard today as when it was first set. There is speculation that the stones for the vault might be reused Roman materials, though the source has not been identified – possibly the Roman town at Aldborough.

Another passage, which now leads visitors to a wooden stair that comes out under the stone choir screen, has a round-headed aperture cut from it at ground level into the main cell of the crypt; the exit is around 4 feet above the floor level there. This is the famous 'St Wilfrid's Needle', through which women suspected of unchastity had to crawl. William Camden, author of *Britannia*, first published in Latin in 1586 and in English in 1610, knew all about it:

> Within the Church, Saint Wilfrid's Needle was in our grandfathers' remembrance very famous. A narrow hole this was, in the Crowde, or close vaulted room, under the ground, whereby women's honesty was tried. For such as were chaste did easily pass through, but as many as had played false were miraculously, I know not how, held fast and could not creep through.

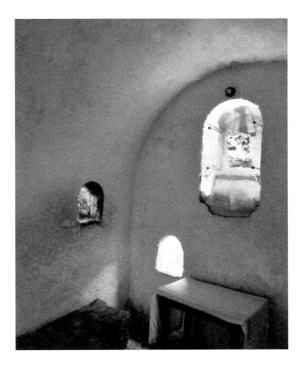

St Wilfrid's crypt; the Needle is on the left.

A writer in 1769 suspected how it might be done:

> They were left there, unable to get out, till they had confessed their fault. Whether the priests had not some craft in this case, by putting some secret barrier across the narrow passage in the dark to impose on the poor girls that were put to the trial, I am not to enquire too far into; however it was, the priests made a miracle of it; and the poor Yorkshire girls, have no doubt, good reason to be satisfied, that St Wilfrid has left off shewing those miraculous things at this time.

It's no longer possible for anyone – chaste or not – to crawl though St Wilfrid's Needle as a panel of glass prevents it.

Even without the trial of the Needle, St Wilfrid is still remembered in Ripon today. Each August the St Wilfrid's Procession is celebrated through the streets of the city, in a revival of a tradition that probably goes back to the thirteenth century when a new shrine to St Wilfrid was consecrated in what is now the cathedral and was then known as the Minster.

In past centuries the saint was represented by a dummy, in a black coat, wig and hat, that was tied to a horse and paraded through the city to the accompaniment of rough music. In the nineteenth century matters became more dignified, with a man dressed in episcopal vestments and sporting a long beard riding thought the streets. The twentieth century saw the development of a procession with decorated floats organised by local groups; there was also a fair, with rides and stalls, on the Market Square. In 2017, for the first time, the part of St Wilfrid was taken by a woman, who eschewed the long beard and wore a red cloak.

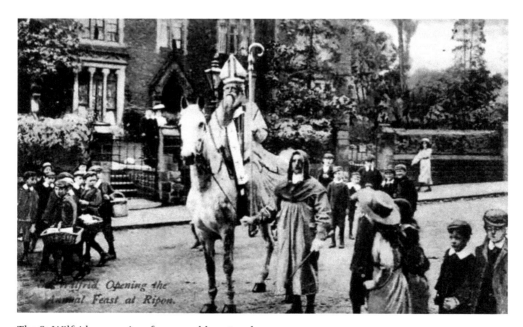

The St Wilfrid procession, from an old postcard.

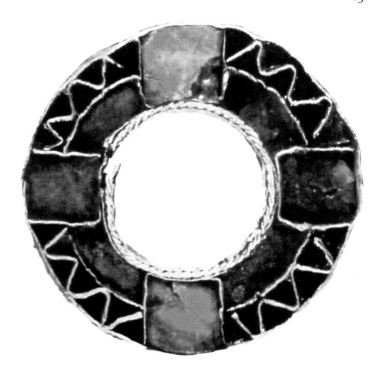

The Ripon Jewel.
(Courtesy of York
Archaeological Trust)

In 1976, archaeologists excavating close to the cathedral found another possible link to Wilfrid: a Saxon decorative piece in the shape of a gold roundel decorated with a cross in amber and with garnets. Dubbed the 'Ripon Jewel', it was possibly the decoration of a piece of church equipment like a cross or a book – it was recorded that St Wilfrid gave his new Ripon church 'a book of the gospels, done in letters of purest gold on parchment all empurpled and illuminated, and had ordered jewellers to make a case for them, also of purest gold and set with precious gems.'

DID YOU KNOW?
In a twist of fate, Cuthbert's body came back to Ripon 306 years after his death. His remains were removed from Lindisfarne when the Danes invaded in AD 875 and were carried by the monks on a century-long wandering journey around the north of England. The body spent almost a year in Wilfrid's monastery in Ripon in 995 before finally being buried in Durham.

2. Cathedral Curiosities

For most of its existence, what we now call Ripon Cathedral wasn't a cathedral. At the time of St Wilfrid, Ripon briefly had a bishop – he was Eadhead, previously bishop of Lindsey and based at 'Sidnacester' (probably Stow in Lincolnshire), who held the newly created Ripon see between 681 and 685. Despite Wilfrid's links with Ripon, he was never styled 'Bishop of Ripon'. After Eadhead, the short-lived diocese was joined on to the see of York to form the new bishopric of Northumbria, which Wilfrid ruled for around five years before being expelled – his was a tumultuous life.

Eventually, Ripon settled down as part of the large York diocese, but it was not plain sailing for the Ripon church. Wilfrid's monastery was sacked by the Danes in around 875, and in 937 Alfred's grandson Athelstan fought an alliance led by the kings of Dublin, Alba and Strathclyde at the Battle of Brunanburh (possibly on the Wirral, but maybe elsewhere – historians have yet to pin down its exact location). His victory, against much larger forces, is said to have been helped by his pre-conflict vow that he would give three

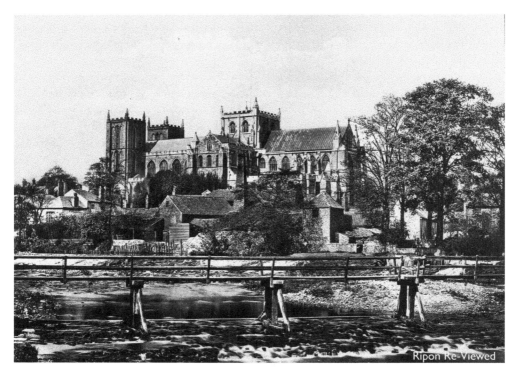

A late Victorian view of Ripon Cathedral from the south-west. (Courtesy of Ripon Re-Viewed)

The remains of the sanctuary cross at Sharow.

churches – York, Beverley and Ripon – special privileges if he won. The fulfilment of this vow may have led to Ripon's 'Liberty' – a wide area centred on the church that ran its own system of administration and justice, outside the king's writ.

Ripon was also a 'chartered sanctuary', allowing fugitives thirty days' safety from arrest under the protection of the church authorities. There were strict rules about sanctuary: anyone seeking it had to confess his sins, surrender his weapons and allow the church authorities to supervise his case. He then had to decide whether to surrender and stand trial or go into exile.

Ripon's sanctuary area extended to at least a mile from the church, and, where its boundary crossed the roads leading into the city, sanctuary crosses were erected. The stump of one remains, at Sharow, just over the River Ure. Made of limestone, it probably dates from the thirteenth century and was given to the National Trust in 1900. It is the Trust's smallest property. Another cross stood in the area of Ripon, now near the canal, known as Kangel – a corruption of 'archangel'. In 2005 Ripon's two rotary clubs reinstated markers – stone gateposts – on the approximate site of the seven lost crosses, and linked them with a 10-mile, circular 'Sanctuary Walk'.

The church buildings were reduced to ruins in 984 when Ripon was burned by King Edred, another of Alfred's grandsons. His justification for his ravaging the town – and, indeed, all of Northumbria – was, according to the Anglo-Saxon Chronicle, 'because they had taken Eric for their king' (that is, the Viking king Eric Haraldsson, better known as 'Bloodaxe'). It continues: 'In the pursuit of plunder was that large minster at Ripon set on fire, which St Wilfrid built.'

How much of the Saxon minster, other than St Wilfrid's crypt, was left after Edred's depredations is unknown, but there was enough to house St Cuthbert's body in 995. After that we know very little until after the Norman Conquest. We do know that at some point the foundation stopped being a monastery and became a college of secular canons – ordained priests who observed the services of the church and undertook its organisation,

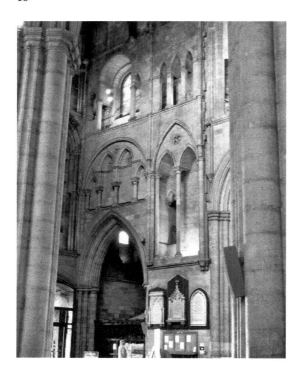

The remaining walls of Archbishop Roger's building.

but, unlike monks, were not bound by public vows of poverty, chastity and obedience. By the end of the tenth century the archbishops of York regularly spent time in Ripon, with a palace on a site immediately to the north-west of the church.

Whatever buildings remained may have suffered again after the Norman conquest of 1066, especially in the Harrying of the North of 1069. By then, of course, the archbishops were of Norman stock – the first of them was Thomas of Bayeux. He may have repaired or even rebuilt the Saxon church, but it wasn't until almost a century later, under another Frenchman, Roger de Pont l'Evêque, archbishop from 1154 to 1181, that Ripon's great minster began to assume its present shape.

If you stand inside the west end of the building, facing east, and then look up at the walls to the north and the south, you'll see part of the nave walls built in Archbishop Roger's campaign. This part of the building was just the width between these north and south walls – there were no aisles. The design is what's called the Transitional style – a combination of the round arches of the Norman style and the newly adopted pointed arches of the Gothic. You must imagine this pattern repeated along the length of the nave – you can see more fragments next to the large arches that support the central tower.

Walter's Theatrical Gesture

Also from Roger's time – and showing the same Transitional mixture of styles – are the north and south transepts and the north and west sides of the central tower, and parts of the walls of the choir, east of the screen. The next-but-one archbishop also left his mark on

Ripon Minster; he was a Norfolk-born Englishman, Walter de Grey, archbishop for forty years from 1215. It's to his building campaign we owe the most impressive part of Ripon Minster after Wilfrid's crypt – the Early English west front.

Walter's decision to enhance the building erected under Roger (and possibly completed by his successor Geoffrey Plantagenet, an illegitimate son of Henry II) may have been to increase the prestige of the shrine to St Wilfrid. Walter had the relics of the saint moved to a new shrine (whether they were really Wilfrid's bones is open to doubt, however, as they may have already been moved to Canterbury) and promoted lucrative pilgrimages to the minster.

The new west front that Walter added is a piece of theatre. His magisterial double tier of tall, narrow 'lancet' windows above the three doorways with their receding rows of columns were intended to impress. The twin towers, too, were meant to instil awe; just think how large the building would have looked in comparison with the tiny, mostly wooden, buildings that surrounded it. The width of the three porches and the façade above was dictated by the width of Roger's nave. The towers, though, projected beyond it – so the building, from the west, looked almost twice as wide as it really was. The current aisles to the nave were added only in the early sixteenth century.

Originally the two western towers, and the central tower, all supported tall wooden spires covered in lead, which would have made Ripon Minster even more imposing. The central spire fell in 1660 'by reason of a violent storm of Winde' and caused severe

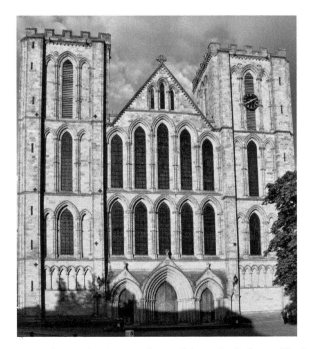
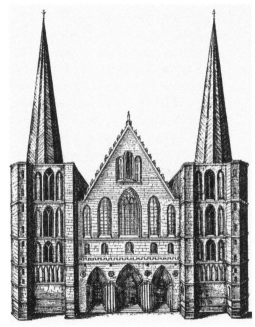

Above left: The west front of the cathedral – Archbishop Walter's theatrical gesture.

Above right: Spires once adorned all the towers of the cathedral.

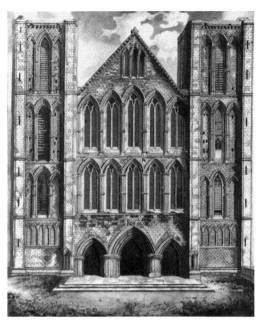

Above left: Gilbert Scott, who restored the cathedral between 1862 and 1872.

Above right: The west front before Scott removed the window tracery.

damage to the chancel of the building. Having to find more than £6,000 for repairs even without reinstating the spire, the dean and chapter decided that it would not be replaced. In 1664 they ordered that the two western spires should also be removed, with the timber and lead sold to help pay for the restoration work. It's related that John Drake, sub-dean, appropriated much of the money for himself.

Between 1862 and 1872 the church – Ripon Cathedral since 1836 – was restored by the leading Victorian architect Sir Gilbert Scott. He was keen to replace the spires, but there was never enough money to do so. He did, though, save Archbishop Roger's west front and towers from collapse (they had very shallow foundations and were dangerously cracked). He also, controversially, removed some extra tracery that had been added to the lancet windows in around 1300. In his *Personal and Professional Recollections*, Scott wrote:

> I have been blamed for the treatment for the windows … The mullions and tracery added were of a very inferior stone and had decayed and given way so as to be only prevented from precipitating themselves into the nave by beams of wood placed across them. I found them beyond the reach of repair, and having once taken them out, the beauty of the earlier design was so apparent, that it seemed barbarous to introduce new ones.

Gilbert Scott was also responsible for two unlikely additions to the building's interior. If you stand under the central tower and look at the passageway above the round arch to the

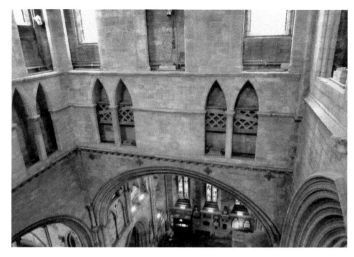

Above left: Scott inserted this girder to stop the central tower collapsing.

Above right: The cathedral's lopsided arch; rebuilding stopped in the late fifteenth century.

north, you'll see something extraordinary in an English cathedral: an iron lattice girder that would be more appropriate in an urban bridge.

This was Scott's solution to one of the building's greatest problems, and it's all connected with the most obvious flaw in the look of the cathedral: the lopsided arches you see as you enter by the west door. In 1450 two sides of the central tower collapsed, severely damaging parts of the choir and the south transept. Rebuilding began – in the latest, Perpendicular, style of architecture – by encasing the columns of the crossing in new masonry and replacing the round arches with pointed ones. Only the eastern and southern sides were completed before the work was abandoned towards the end of the century. This left the western arch is still round, but with its southern pillar already built up to receive the new pointed arch.

As well as leaving the arches looking odd, the failure to finish the reconstruction had disastrous consequences for the tower. It meant that two of the sides – the east and the south – had been renewed, while the other two sides were still the earlier structure; you will notice that the tower is not a regular square. When Scott inspected the building for his restoration he reported that the tower 'was and is a curious union of twelfth and fifteenth century work, two sides of each date. It had given way from this strange union, the older work falling away from the later. It was in a dangerous state'. So he had to act. And his solution was to stabilise the structure by inserting this huge iron beam to help tie the two sides together.

We can see the influence of Scott throughout the cathedral. His workmen put in place the stone vaulting of the north and south aisles of the nave, laid down the patterned floor in the choir (it's worth having a close look at the stone they used; it's local limestone marble of two colours that is teeming with fossilised creatures like bellamites and crinoids) and carved the canopies for most of the choir stalls – only a few had survived the collapse of the central spire in 1660.

Misericords – and Alice

In the seats below these mainly Victorian canopies is another of Ripon's secrets: thirty-two misericords, dating from the end of the fifteenth century. These tip-up seats provided a ledge to support standing clergy during long services, but below the ledge the carvers provided spirited vignettes of contemporary life, ironical comments on religious attitudes and mythological figures. They include a woman being wheeled in a barrow, a pig playing the bagpipes while others dance, a fox in a pulpit preaching to geese, a mermaid with a mirror and Samson carrying off the gates of the city of Gaza.

Two other misericords link the cathedral to Charles Lutwidge Dodgson – Lewis Carroll – who spent some of his youth in Ripon; his father was Archdeacon of Richmond and a canon of the cathedral. One shows a gryphon chasing a rabbit, while another scuttles down a rabbit hole – just as the White Rabbit in *Alice's Adventures in Wonderland* popped down its hole in the book's first chapter. The other includes odd headless creatures known as 'blemya', whose face appears upon their chest (one unusual example – as it consists of just a head and a pair of legs – is even seen wearing a fetching fifteenth-century hat). When Lewis Carroll drew his idea of Alice when she shrank, he depicted her as just such a creature.

And if you want to see other 'Alice' links in the cathedral, one of the gilded roof supports in the south transept has carvings that show a queen (usually interpreted as the Queen of Hearts) and an enigmatic cat face – perhaps the Cheshire Cat, though its smile has faded somewhat. *Alice's Adventures in Wonderland* was published in 1865 while the cathedral was being restored by Scott, and it's thought that these details were added at that time.

The misericords were made by what's known as the 'Ripon School of Carvers', led by William Bromflet at the very end of the fifteenth century. They also carved the ornate bench ends. Most of these are stylised bundles of leaves, but some are more elaborate; on the bishop's (originally the Archbishop of York's) throne the finial is an elephant with a tower on its back, often interpreted as an allegory of the Church, while opposite is the mayor's (originally the wakeman's) seat, with an insouciant monkey – perhaps a piece of fifteenth-century satire.

Bromflet's craftsmen were, it seems, keen to subvert the solemnity of the church. As well as the comments on life, the church and the authorities on the misericords, one of them carved an image of a man who is exposing himself to the curious viewer in one of the canopies on the north side of the choir. More useful, and almost as startling, is

Misericord of a gryphon and rabbits, which inspired Lewis Carroll.

Curious 'blemya' figures appear each side of this misericord.

Carvings of the Queen of Hearts and Cheshire Cat.

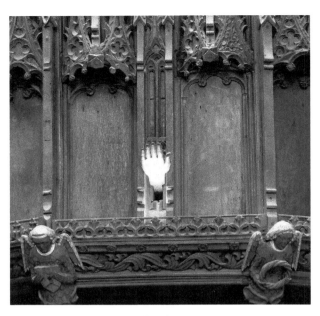

Above left: The bench-end of an elephant and castle, representing the Church.

Above right: This mechanical hand formerly gave the beat to the choir.

the wooden hand that projects from the balcony above the entrance archway, below the organ. Its purpose was to beat time for the choir, and it was originally operated by the organist with a foot lever. It still can still move up and down (now with a hand lever), but it's no longer used for conducting.

Another, more modern piece of carving can be found on the side of the mobile organ console that is in the nave. The organ that sits on the screen can be played from here as well as from the original screen console. This moveable one, connected by a remarkably thin (and long) cable, was donated by a cathedral music supporter surnamed Beer – hence the barrel carved on the side panel.

Of much the same date as the late fifteenth-century choir stalls are three alabaster panels – one, showing Christ rising from the tomb, is in St Wilfrid's crypt. Two others are in the chapel in the north transept; one has the Coronation of the Virgin and the other is a figure of St Wilfrid. They have all been repainted, but are unlikely survivors. In 1567 five of the minster's clergy were taken to a church court. The charge was that they 'took the keys of the church from one John Day, the sacristan there, and that night all the images and other trumpery were conveyed forth of the said church and bestowed by the said vicars where it is not known'. The men were keen to preserve some of the Catholic images of the past – and in fact they had not taken these alabasters 'forth', but had buried them near the dean's stall in the choir, where they were discovered in the nineteenth century.

Nearby is the great fifteenth-century stone screen with its colourful modern statues – they were put in place in 1947 and were painted and gilded a decade later. An older figure is found nearby, on top of a very tall plinth attached to the east face of one of the columns

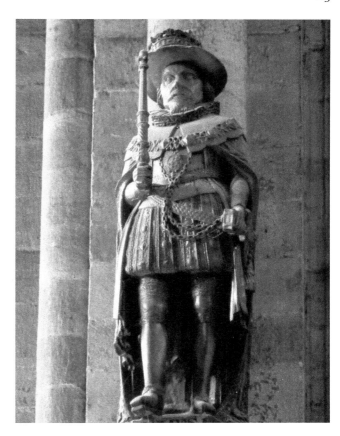

The statue of James I was made
for York Minster.

of the crossing. He is James I; his almost-life-sized statue, complete with crowned,
wide-brimmed hat and sceptre, was made for the screen of York Minster in 1603 but was
removed from there and given to Ripon in 1811 – appropriately, as James I gave the dean
and chapter of the minster a new charter in 1604, at the same time as he gave a charter to
the city.

A Pulpit like a Tiger

In 1913 the cathedral was given a new pulpit. It is a masterpiece of Arts and Crafts
design by architect and metalworker Henry Wilson, made of beaten copper with silver
and enamel decoration. It was the gift of Canon Howard Stables of Headingley, who is
commemorated in the bold zig-zag inscription. The shape of the pulpit mirrors that of the
column behind it, which is embraced by the simple curving stairway. The main figures
below their respective shields are St Cuthbert, St Hilda, St Chad and St Etheldreda. Look
carefully under the arches at the top of the Italian marble columns to see plenty of other
small figures – not just cherubs and saints, but also the head of the pagan god Mercury,
complete with winged helmet.

Wilson wanted the design to 'spring ... like a tiger from its lair'. He also designed a
sounding board to hang above his pulpit, which was painted with clouds and supported

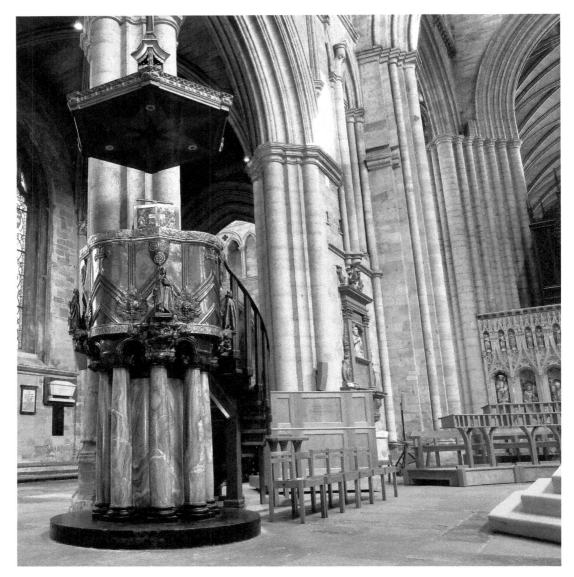

The 1913 pulpit, designed by Henry Wilson.

with a metal frame with planet-like spheres. This was removed in the 1920s; the current sounding board, put up in 1960, is said to have previously been the top of a table in the deanery.

In 2012 the west end of the cathedral was transformed with new glass doors, allowing the seventeenth-century wooden main doors to remain open during the day and let light flood in. Designed by the cathedral's architect Oliver Caroe, this narthex or porch

has glass panels engraved by Sally Scott that refer to the life of St Wilfrid. The open doors also provide a dramatic sight in the evening when the interior is lit – especially each 2 February, when the Feast of Candlemas is marked by the lighting of thousands of candles and celebrated with a eucharist and procession. Candlemas is an ancient ceremony, marking the presentation of the child Jesus in the Temple at Jerusalem. Despite the religious upheavals of the sixteenth century the tradition survived in Ripon. In 1709 a visitor to 'that pleasant market town Ripon' saw that 'the collegiate church, a fine ancient building, was one continued blaze of light all the afternoon from an immense number of candles'.

There are many monuments in the cathedral that repay close attention; we'll look at three of them. The most elaborate and noticeable is in the south transept, to William Weddell of Newby Hall. It is based on an ancient Greek monument in Athens called the Choragic Monument of Lysicrates, and has a bust of Weddell by the great eighteenth-century English sculptor Joseph Nollekens. Weddell was a connoisseur and collector of art; his sculpture gallery, designed by Robert Adam, can be seen at Newby. The inscription on the plinth describes the monument (which was originally surrounded by railings) as 'a faint emblem of his refined taste'.

In the north choir aisle is a sad monument to the children of Dean James Webber, who died in 1847. The inscription is in Latin, except for a verse from Tasso's *La Gerusalemme Liberata* in Italian that commemorates Jemima Webber, who died aged fourteen. Among the others remembered are Edward, who drowned in the Thames, aged fifteen; Cyril, who died suddenly aged seventeen; Caroline, who died '*in cunabilis*' – in the cradle; and Charles who was killed by '*machinæ ictu igniferæ*' – the blow of a 'fire-machine': he was struck by a railway engine.

Finally, on the east wall of the south-west tower is the monument to the Oxley family. Admiral Oxley and his wife, Emily, are commemorated, as well as their seven children; the children were a wild lot, known as 'the Terrors of Ripon'. Most of the children lived to a ripe old age; the last, Dorothy, who was married to the 14th Viscount Arbuthnot, died in 1990 aged 100. Yet on the monument they have preserved their youth, for the whole family is portrayed around the end of the nineteenth century, their impassive faces observing us, each arising from a pair of angel wings. The effect is charmingly cherubic for the children, but decidedly odd for the heavily moustached admiral.

On the churchyard wall to the east of the cathedral is a small plaque that commemorates the last resting place of hundreds of skulls and bones that were removed from the vault beneath the chapter house when Gilbert Scott restored the cathedral between 1862 and 1872. The inscription reads: 'Under this stone, in pit twelve feet deep, the extent of which is marked out by boundary stones, a portion of the bones that were in the crypt under the south-east part of the cathedral, were buried in May 1865.'

The bones were from the charnel or bone house and were probably the remains of Riponians originally buried in the graveyard whose remains were later moved to make room for more interments. A more romantic tale is that they are were gathered from 'the bleached battlefields' of the War of the Roses and the Civil War.

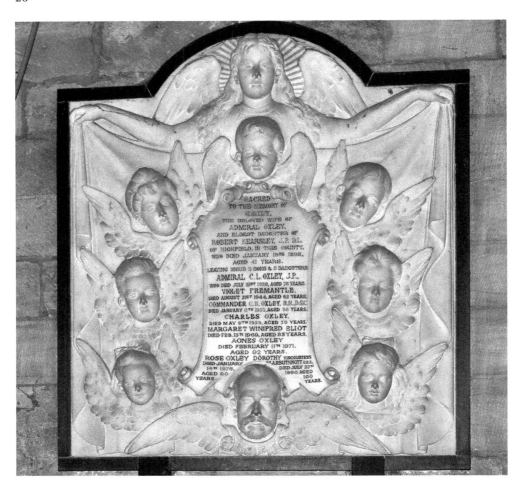

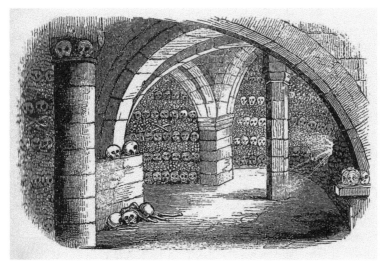

Above: The cherubic Oxley family in the cathedral's south-west tower.

Left: The charnel house was once one of Ripon's tourist attractions.

The charnel house was one of the tourist sights of Ripon in the eighteenth and early nineteenth centuries. Dr Augustus Granville, in his 1841 book *Spas of England*, wrote:

The massive door was open, and I descended into the crypt, the three vaulted arches of which are filled with skulls and detached jawbones, with leg and thigh bones, in some parts piled twelve feet deep inwardly, and seven feet in height ... The floor ... is strewed with skulls, lightly covered over with a thin coating of yellow sand. This in some places may be brushed off with the feet, when suddenly the eyeless sockets of some unknown genius, destined to perish in obscurity in life as well as in death, stares you in the face; or the gaping jaws of some decrepit lawyer yawn like the portal of death.

This once-grisly place now houses the choir rehearsal room and the Chapel of the Resurrection.

DID YOU KNOW?
Thorpe Prebend House provided a comfortable bolthole for the last abbot of Fountains Abbey, just west of Ripon. Having been put into his office by Henry VIII, he surrendered the monastery to the king in 1539. Already a prebendary of Ripon (a post he had cannily refused to relinquish when made abbot), he quickly moved into Thorpe Prebend House and lived on a generous pension of £100 a year.

Around the Cathedral

The cherubic Oxley family (*see* page 25) lived just beside the cathedral, in the handsome red-brick house immediately to the south on Bedern Bank. Built for them in the eighteenth century, it used to be called The Hall, but is now Minster House and the private residence of the Dean of Ripon. Following the path through the graveyard along the cathedral's south side and bearing left down steps, you will reach the gates to another of Ripon's fine eighteenth-century brick houses, the Old Hall of 1738. In the nineteenth century one of its residents was the Venerable Charles Dodgson, Archdeacon of Richmond and a canon of the cathedral. From 1852 to 1858 he and his family, including his writer son Lewis Carroll, lived here for three months of each year. There is a Ripon Civic Society plaque on the gatepost; the house is in private hands.

Opposite the gates is the Cathedral Hall, on the site where Ripon Grammar School used to stand. Tradition says that Ripon's first school was here; St Willibrord, who became patron saint of the Netherlands and Luxembourg, was taught here by St Wilfrid in the seventh century. There was certainly a school here by the fourteenth century. It was refounded in 1555 by Mary I and her husband, Philip II of Spain. The foundation was to teach local boys of all classes, but for a time it became a fee-paying school; local people protested at the change. New statutes for the school in 1837 reversed this policy, but fees were reintroduced in the 1870s, though they were kept as low as possible.

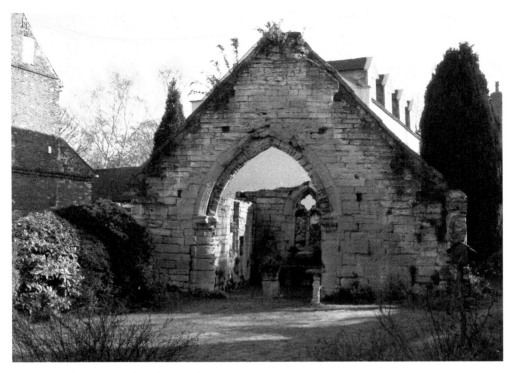

The ruins of St Anne's Chapel on High St Agnesgate.

Thorpe Prebend House entertained both James I and Charles I.

By this time parents had started to object to the school's 'unhealthy situation' and its 'old and incommodious premises', and the school was moved to a new site in 1874 (*see* page 58).

High St Agnesgate runs along the bottom of the ridge that the cathedral sits on. The street's name is a corruption of St Anne's Gate, from the Hospital of St Anne. The ruins of the medieval chapel of the hospital, which provided a home for eight old people, still show the arrangement of the building. The now-roofless east end of the building was the chapel; the vanished 'nave' part was partitioned into a male and a female dormitory. A chaplain also had a room. In 1869 new almshouses were built alongside the ruins.

Next door is Thorpe Prebend House – where successive minster canons who held the 'prebend' or revenues of the neighbouring village of Littlethorpe formerly lived. The best view is from the New Bridge (new in 1809), from where you can see its two wings. Part of its wooden frame goes back to medieval times. Among its distinguished visitors it can count Mary, Queen of Scots, James I and his son Charles I.

Further to the east along High St Agnesgate is the birthplace of writer Naomi Jacob. Her father was headmaster of the cathedral school, and she was born here on 1 July 1884. She combined an acting and broadcasting career with writing more than seventy successful novels. Monocle-wearing and with cropped hair, she entertained troops in the Second World War with her humorous sketches. She died at her home at Sirmione in Italy on 27 August 1964.

The Liberty Courthouse, built in 1830, is now a museum.

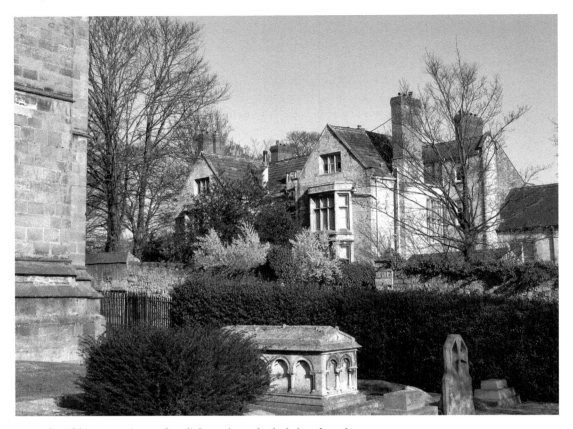

The Old Deanery (now a hotel) from the cathedral churchyard.

The area to the north side of the cathedral – now crossed by Minster Road – has a long ecclesiastical history. The archbishops of York had a summer palace in this area; in the 1530s the antiquary John Leland wrote, 'The Prebendaries houses be builded in places near to the minster, and among them the Archbishop hath a fair palace.' All that's left of the palace is a timbered gateway in Kirkgate, but opposite the west end of the cathedral is one of Ripon's oldest structures: the Old Court House, hidden behind a medieval wall to the west side of the green.

From here the 'Canon Fee' – the area of land within the archbishop's holdings held by the canons of the minster – was administered. The long main range of the building probably dates from the fourteenth century and may possibly include materials from the former palace. The timbered part may have once stood alone as a kitchen block and was later joined on to the main structure, where the hall on the upper floor was a courtroom. The lower floors were used as a prison, with cells and rooms for the gaoler. The building remained in the church's possession until the 1950s; it is now a private house.

At right-angles to the Old Court House is the Liberty Courthouse. The medieval Liberty of Ripon survived as a legal quirk after the Reformation and was zealously guarded by successive archbishops and by the city fathers, until national reform of the legal system

in the first half of the nineteenth century. To mark this change this new courthouse was built in 1830 as a replacement of an early building that was on the site of the former palace of the archbishops. The quarter sessions were held here until 1953, and magistrates' courts until 1998. The courtroom is now cared for by Ripon Museum Trust as a virtually unchanged Georgian courthouse and is open to the public.

East of the Courthouse is the former deanery – now the Old Deanery Hotel. In the Middle Ages this was the site of the Bedern, where the clergy who sang the day-to-day services of Ripon Minster were housed. By the end of the sixteenth century the Bedern was in bad repair, and after the Reformation it was home to a few poorly paid priests. There might have been a university founded on the site in the late sixteenth century; Queen Elizabeth I's adviser Lord Burghley supported the idea, but Her Majesty was not convinced, so Ripon did not develop into a rival to Oxford and Cambridge.

After James I re-established the minster with a college of canons in 1604, a new building, for the minster's dean, was constructed on the site of the former Bedern. Inside it has a Jacobean staircase; alterations were made to the building in 1799 and in the nineteenth century, and a new staircase extension was added in the early twenty-first century. The Old Deanery has been a hotel for many years and is said to be haunted. Visitors have sensed the presence of a former dean when going down the stairs, a female figure – named as Jenny Wanlass – has been seen walking through a blocked-up doorway, and the ghost of an Anglo-Saxon monk has been seen in the garden, near to where buildings of St Wilfrid's monastery once stood.

DID YOU KNOW?
There were special foods for the Feast of St Wilfrid – Wilfratide. 'Wilfra Tarts' were sweet pastry cases filled with a mixture of bread, butter, sugar and milk, flavoured with lemon rind and almond essence. They are still occasionally made.

3. Square Roots

The Market Square is the commercial heart of Ripon – and in some ways its administrative heart too. The original marketplace was probably laid out in the twelfth or early thirteenth century by one of the archbishops of York. Arranged around it were carefully measured house plots for which craftsmen could take tenancies. These were 'burgage' plots (held by burgesses) and these still mould the layout of the city centre. The city already had a royal market charter from around 1108. Originally the marketplace was much larger, stretching down at least as far as what is now called (and has been since at least the end of the fourteenth century) Old Market Place. It had a market cross and attendant stocks, pillory, whipping post and gallows.

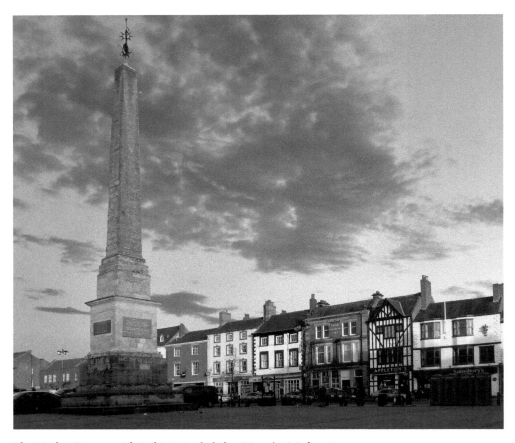

The Market Square, with its historic obelisk – Ripon's civic heart.

The square took much of its current shape at the beginning of the eighteenth century. Local magnate John Aislabie of Studley Royal was Mayor of Ripon in 1702, and he commissioned the prominent architect Nicholas Hawksmoor to redesign the city centre. Hawksmoor intended it to be an open *forum populi*, based on Rome's Piazza Navona. For the centre of his forum he designed an obelisk 'according to the most exact antient symetry' based on the Vatican obelisk. This is the earliest freestanding obelisk in Britain, and cost £564 11s 9d. Take little notice of the inscription on it that suggests it dates from 1781 and that it was built by William Aislabie, John's son. He paid only for a reconstruction.

The obelisk's design was criticised for not providing shelter for market traders. Hawksmoor then produced a drawing showing a circular structure painted with the star of the Order of the Garter as 'a projecture that in time of rain will shelter ye market people'. This was soon forgotten; it was totally impracticable, anyway.

When Daniel Defoe came to Ripon in the early 1720s he described the new square as 'the finest and most beautiful square that is to be seen of its kind in England' and noted that 'in the middle of it stands a curious column of stone, imitating the obelisks of the ancients, though not so high'.

It seems that Defoe wasn't around in the evening during his visit to Ripon (he had come from Ripley and was headed for Boroughbridge) or he would undoubtedly have mentioned ceremony of the horn blowing that takes place at the obelisk every day. You will see that the weathervane on the top of the obelisk is in the shape of a horn. In fact, there are horns everywhere you look in Ripon, carved horns, painted horns, horns in stained glass, horns in cast iron and in bronze. One of the city's secret pleasures is horn spotting.

To Riponians the Hornblower is part of the city's fabric, as familiar as the cathedral, but is not so well known by outsiders. Each evening at 9 p.m., in rain, hail, fog or snow, darkness or sunshine, the Hornblower (these days there is a rota of four), dressed in buff coat and tricorn hat, approaches the obelisk and blows one of the Ripon horns, once at each side of the monument. It's a unique ceremony in the United Kingdom.

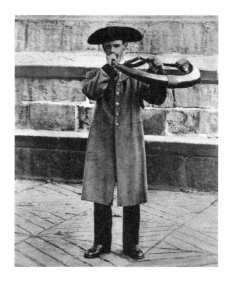

Ripon Hornblower standing beside the obelisk – from an old postcard.

There are five horns owned by the city. The oldest is the Charter Horn, which is covered in black velvet with silver mounts and is hung from a wide baldric that is worn by the city's sergeant-at-mace on ceremonial occasions. There is a claim that this horn was presented in 886 by King Alfred after reaching an accommodation with the Danes. This story has long been doubted; the dates don't work for it to be possible. Nevertheless, the city celebrated its 'millenary' in 1886 with widespread junketing. To mark the event they bought a new horn, known as the Millenary Horn.

A century later another festival was held and another horn was bought: the 1986 Festival Horn. The horn that's usually blown these days is the 1865 horn, which was given by Mayor Benjamin Pulleine Ascough in the year that the City of Ripon Act made the place officially a city. The other horn that sometimes appears on the square is the Reserve Horn, which dates from 1690 – the year that the charter given by James I in 1604 was confirmed; there was confusion about the status of such charters after the Glorious Revolution of 1698, when James II fled the throne and William and Mary took over as joint monarchs.

What is the purpose of all this horn-blowing, which has certainly been going on since the Middle Ages? A functionary called the wakeman was appointed (originally by the minster authorities) who was responsible for setting the watch each evening and maintaining the curfew from 9 p.m. to early morning. Each citizen paid 2d for every street door; from the funds, the wakeman had to compensate the householders if they were burgled overnight.

Ripon citizens have always been canny. As the charge of 2d was halved to a penny if your door was on a passageway, they began to build houses with side doors; the multiplicity of passageways and courtyards in the city even today (many of them now

An alleyway off Westgate – one of many in Ripon.

closed by doors and gates) is a legacy of this opportunistic parsimony. The wakeman himself may originally have blown the horn to declare that the watch had been set, but soon, as an important municipal official, he deputised the blowing to a specially appointed Hornblower. After blowing the horn beside the obelisk (and these days, telling visitors assembled to hear it about the history of the ceremony), the Hornblower then goes to find the mayor, if he or she is in the city; there the horn is blown again and the Hornblower announces 'Mr Mayor (or Madam Mayor), the Watch is set.' So if the mayor's in the pub, or at a concert in the cathedral, or a dinner in one of the hotels, everyone present enjoys part of a ceremony that has been going on daily in Ripon for many centuries.

DID YOU KNOW?
The name of Lavender Alley, which joins Fishergate and Old Market Place, is probably a joke; the alley was probably extremely noisome and miasmic in the past. A similar passage in St Albans was known as Lavender Alley or Bog Alley and ran through an area densely packed with buildings and yards, just as here. The alley is probably on the line of the former Crossgate, which crossed the marketplace when it was much larger.

The Wakeman – and Not His House

Under the 1604 charter the wakeman was rebadged as the Mayor of Ripon. Hugh Ripley was the last wakeman and first mayor – a dumpy statue of him can be seen on his monument in the cathedral, near the pulpit. In the south-west corner of the Market Square is what's known as the Wakeman's House, reputedly the home of Ripley. Unfortunately, there is no evidence to link Hugh Ripley with this building, but despite its incorrect name,

The Wakeman's House, where the Wakeman never lived.

it's an interesting structure. It's all that remains of a late medieval house – this was just one wing, and the house previously faced into High Skellgate. It was altered to have its current entrance into the square in around 1600. Eventually, the rest of the house was demolished.

The inside of the building, which been used as a teashop, tourist information centre, offices, a dress shop and, once again, as a teashop, has a tiny musician's gallery, and on one wall you can see the exposed wattle and daub that fills the spaces between the building's timber frame. The exterior timbers were never intended to be exposed, but the lime plaster coating was removed in the early twentieth century, when the building was bought by Ripon City Council and opened as a museum.

We know, in fact, that Hugh Ripley lived a few doors to the west, at what is now No. 37 Market Place South. Ripley's house no longer stands here, but by the 1730s it had been rebuilt in its current form and was home to the Chambers family. They were mostly merchants, with particular interests in Sweden, and it was in Gothenburg that the most famous of them, the architect Sir William Chambers, was born in December 1722.

As a boy he was sent to Ripon Grammar School and lived in this house, then the home of his uncle, a surgeon also called William Chambers. In later years the architect remembered Ripon fondly for its 'lovely bowers of innocence and ease, seats of my Youth'.

He travelled to Bengal and China with the family firm, then set up in architectural practice, studying in Sweden, France and Italy. He became one of Britain's most famous architects; he tutored the future George III in architecture and designed the Pagoda in Kew Gardens for the Dowager Princess of Wales. Among his other designs was the gilded State Coach used at British coronations.

The house was also the childhood home of Edmund Ayrton, the most successful of a Ripon family of musicians who provided organists for the minster for several generations. Edmund was a chorister at York Minster, where he studied the organ, and he later sang in the choir of St Paul's Cathedral, before becoming Master of the Children (i.e. the choristers) of His Majesty's Chapel Royal. A composer of church music, he was also involved in recruiting singers for the opera at Covent Garden. A fellow composer, Samuel Wesley, described Ayrton as 'one of the most egregious blockheads under the sun'. Master Ayrton was accused, though acquitted, of starving the boys in his care, but on his death in 1808 he was genuinely mourned.

A later incarnation of No. 37 Market Place South was as Ripon's main post office and then as the Lawrence Restaurant and Ballroom, a favourite venue for dance bands and 'hops'. It was briefly a casino before becoming the Halifax Building Society – now the Halifax Bank – in the late 1960s.

DID YOU KNOW?
In the early 1920s the Wakeman's House was restored and an opening ceremony was held, which included the Hornblower sounding the horn. The house was locked and empty, but when the horn sounded several of the crowd saw, looking from an upper window, the face of a man. The house was unlocked but no one was found inside. Everyone believed it was the ghost of Hugh Ripley – the man who never lived here.

When Is a Town Hall not a Town Hall?

The major structure on this south side of the square is the Town Hall. Announcements have been made and new monarchs proclaimed from its balcony; every New Year's Eve the civic party stands here to lead the countdown to midnight. It is the very epitome of civicness.

Yet, oddly, it wasn't really built to be the Town Hall. Dating from the very end of the eighteenth century, it was designed as a new Assembly Room for Ripon and paid for by Mrs Elizabeth Allanson, granddaughter of John Aislabie and heiress to the Studley Royal estate. Mrs Allanson lived mostly near London and rarely visited Ripon, and she is likely to have influenced the choice of the fashionable London designer James Wyatt as the architect for what became the Town Hall.

The foundation stone for the new building was laid by the mayor, William Atkinson, on 2 February 1798. It reported: 'Afterwards, a most liberal entertainment, of every variety the season could afford, was given to the Corporation and gentry of the town by the mayor at his own house; several loyal and patriotic toasts were drunk, and the evening concluded with the utmost harmony and conviviality.' Once the Assembly Room opened, such convivialities were often held there, as well as public meetings. Sometime the city council met there, but often it met elsewhere, including at the Unicorn Hotel. By the later nineteenth century the Assembly Room building was recognised as the home of civic administration and was generally known as the Town Hall.

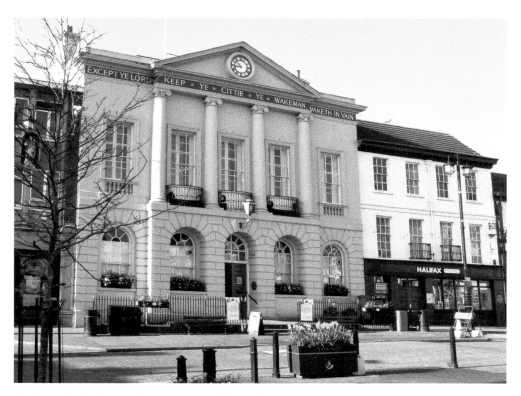

The Town Hall's foundation stone was laid in 1798.

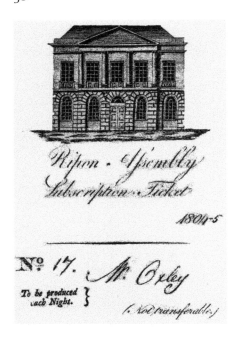

Mr Oxley's subscription ticket to the
Ripon Assembly.

When Ripon celebrated its Milennary festival in 1886, the quotation from Psalm
127, starting 'Except ye Lord keep ye cittie', was painted on the frontage, with the word
'Wakeman' subsitituted for the original 'Watchman' to celebrate Ripon's long tradition of
the Hornblower. At that time the Town Hall was owned by the Marquess of Ripon, whose
family was related to Mrs Allanson. In 1896, when the marquess was also Mayor of Ripon,
council members asked him to undertake much-needeed repairs to the building. On his
last day in office he wrote to them, 'It has for some time seemed to me an anomaly that the
Town Hall of Ripon should belong to a private individual and not the Corporation. I have
determined to make a free gift of the Town Hall site and buildings to the Corporation.' So
the marquess neatly avoided the costs of repair as the council took over the ownership;
a plaque inside the entrance notes in a slightly exasperated way that it was 'finally' given
to the corporation. Since local government reoganisation in 1974 the Town Hall has
belonged to Harrogate Borough Council.

There's a portrait of the building's foundress, Mrs Allanson, in the main Assembly
Room – now more prosaically known as the Council Chamber – and a diminutive minstrel's
gallery high on the south wall to remind us of its original purpose. Downstairs to the left of
the main door is the Mayor's Parlour, where some of the civic treasures are kept; occasional
talks allow visitors to learn about a collection that goes back several hundred years. The
room to the right of the entrance is now Ripon's Tourist Information Centre.

Continue further along the south side of the square and you'll find a building that
obviously betrays its 1960s origins. At the end of the nineteenth century a large and
elaborate structure was built here to house the Claro Bank. The bank was eventually
taken over by the National Provincial, which in 1961 applied for permission to demolish
the sixty-two-year-old building. They said they would 'make every effort to preserve the
architectural character of the Square'. You may judge for yourself how they succeeded

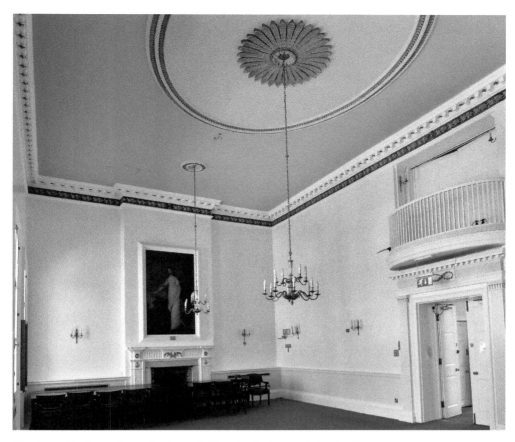

The Assembly Room (now the Council Chamber) with musicians' gallery.

(the ground floor is a later change). They did, though, keep part of the 1899 building: a statue of St Wilfrid that formerly graced a niche in the topmost gable of the bank. He's still there, high up on the new building, in protective concrete shell. Since he went up, he's always been referred to as 'St Wilfrid in his bath'. The National Provincial became part of the NatWest, which closed the bank here in 2018.

DID YOU KNOW?
Two ornate lamps illuminate the presence of the Mayor of Ripon. One is fixed over the entrance to the Town Hall and was purchased by the council in 1892. Its design was described as 'a very neat one. It is ... surmounted by a crown, and on the sides of the glass facing the street, are the words, "The Right Worshipful the Mayor".' The other moves; a 'pillar gas lamp', it is installed (if mayor lives within the city) outside the mayor's residence for the year of the office. This lamp dates from 1900.

Boots and Bellman

On the east side of the square is the Unicorn Hotel, which stands on a site that has probably been used for an inn since the Middle Ages. By the seventeenth century it was a regular meeting place of the mayor and council, and a stopping-off place for travellers; the doughty tourist Celia Feinnes complained in 1697 that in Ripon 'some of the inns are very dear to strangers that they can impose on'. The original medieval timbered inn was extended and given its current Georgian frontage in the 1750s.

Many travellers arrived at the Unicorn by coach as the hotel was one of the stopping places on several coach routes, including the London to Glasgow Mail and the Telegraph coach between London and Newcastle. Other coaches connected with routes along the Great North Road. The Unicorn's main rival was the Black Bull, now the SO! Bar, in Old Market Place.

From the 1760s until the early part of the nineteenth century the most famous character at the Unicorn was Tom Crudd – known as 'Old Boots' – who helped travellers put on and take off their boots. The *Wonderful Magazine* printed a picture of him in 1807 and noted:

This extraordinary person was favoured by nature with a nose and chin so enormously long, and so lovingly tending to embrace each other, that he acquired by habit the power of holding a piece of money between them. The company in general were so diverted by his odd appearance that they would frequently give him a piece of money on condition he held it between his nose and chin. This requisition he was always ready to comply with, it being no less satisfactory to himself than entertaining to them.

Lewis Carroll knew about Old Boots, and also about Ripon's Bellman, who at 11 a.m. each Thursday rings a hand bell to mark the official opening of the weekly market – though trading will have been going on for several hours already. The Bellman has been part of

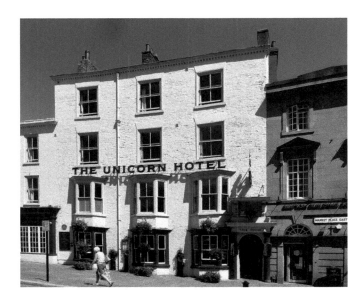

The Unicorn Hotel, a coaching inn in the eighteenth century.

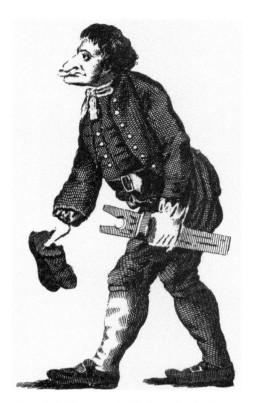 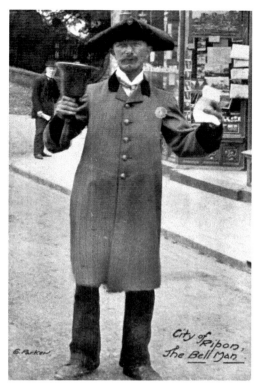

Above left: The remarkable Tom Crudd, boot-man of The Unicorn.

Above right: The Bellman declares the market open each Thursday.

Ripon traditions since at least the fourteenth century. Like the Hornblower, the Bellman today dresses in a buff coat and tricorn hat. Carroll's memories of Boots and Bellman resurface as characters in his long poem 'The Hunting of the Snark', where there is also a 'Beaver, that ... would sit making lace in the bow'. Ripon had its own lacemaking tradition, whose practitioners would sell their crafts on the Market Square.

Almost next door to the Unicorn Hotel is the building now occupied by Sainsbury's. This used to be the Crown Hotel. In the seventeenth century the site was occupied by another inn: the White Hart. The Crown closed in 1907 and for many years the premises were occupied by Croft and Blackburn's garage, before conversion to a supermarket.

The inn was marked by a large carved crown. When the Crown closed this was kept in Ripon's former museum for many years, but after its closure Ripon Civic Society organised for the crown to be replaced on the building. It was put up in 2003, but over the years it gradually deteriorated. In 2014 the crown fell from its position, shattering on the pavement below, narrowly missing pedestrians. Now restored, it can be seen safely inside the store, over the trolley ramp at the car park end.

On the Market Square opposite Sainsbury's is one of Ripon's rarities, the cabmen's shelter. Before motor taxis were introduced, horse-drawn cabs would queue here to wait

The Crown Hotel sign, now restored and inside Sainsbury's store.

for customers – many of them needing to get to the station, a mile to the north. By the end of the nineteenth century there were worries that cabmen waiting for fares would spend their time drinking in local pubs.

In 1904 the city council agreed to spend £60 for 'a suitable shelter for the protection and shelter for the cab and coachmen', but it was not until 1911 that the then Mayor of Ripon set up a fund to make this a reality, promising to provide newspapers and magazines for the cabmen to read while waiting for hire. No sooner had the fund been set up, however, than the executors of Sarah Carter, whose father Thomas, a draper, had been a former mayor, came forward with a bequest to the city that covered the entire cost, which had now risen to £200.

The shelter was purchased from the Norwich firm of Boulton & Paul, famous for their portable buildings, including henhouses and shepherds' huts. When motor taxis replaced horse-drawn vehicles, the shelter lost its purpose and fell into disrepair. In 1984 it was given to Ripon Civic Society, which arranged for it to be repaired by the Royal Engineers, for many years stationed in Ripon. The engineers supplied the current wheeled chassis. Ten years later the shelter was damaged by a lorry, and Civic Society members repaired and repainted it before presenting it to the city council on New Year's Day 1999. In 2009 the society successfully applied to have it made a listed building; the four adjacent phone kiosks are also listed.

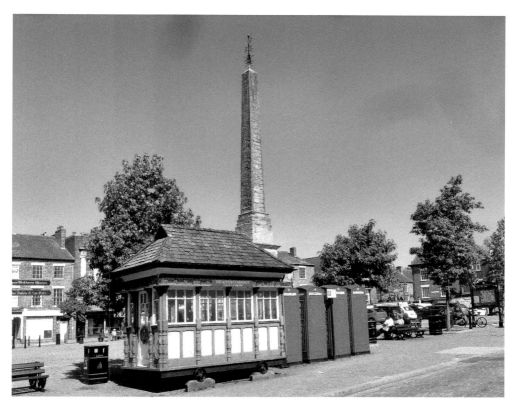

The cabmen's shelter – away from the temptation of pubs.

For a city with a medieval layout it comes as a surprise that Queen Street, which enters the Market Square in its north-east corner, is so wide. It was not always so; there were once two narrow thoroughfares, with a block of houses and shops between. To improve the traffic flow in the city (as much a problem at the start of the twentieth century as now) the buildings were demolished. Work started in December 1902, but one shopkeeper, Mr Rayner the draper, held out for better compensation, so his store stood alone until he agreed to accept £4,872 three years later.

Many of the buildings around the square have eighteenth- and nineteenth-century frontages, though behind them there are often the remains of earlier timber-framed structures. Then there are the half-timbered buildings, including Appleton's butcher's shop on the east side and a group on the square's north-west corner. Do not be fooled; these are pastiche timbers, erected at much the same time as the Wakeman's House had its external plaster removed to expose its (genuine) wooden frame.

There are a few, more ancient, timbers on display nearby – at the entrance to the passage on the left of Boots. They tell a sad tale. There was a house on the site, probably originally built in the sixteenth century. By the late eighteenth century the premises had become the York Minster Inn. The inn closed in 1828 and the premises became an ironmongers and jewellers. By the end of the nineteenth century the property had changed hands again

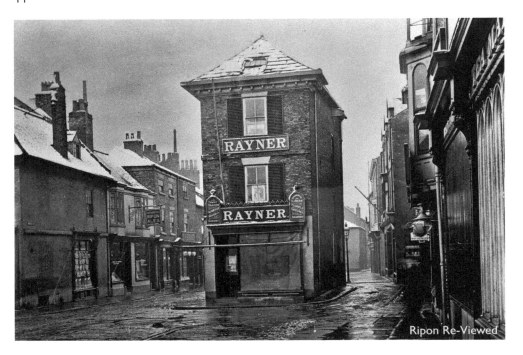

Ripon Re-Viewed

Above: Rayner's shop in Middle Street was last to be demolished. (Courtesy of Ripon Re-Viewed)

Left: Ripon's coat of arms from the Café Victoria, now in Boot's store.

and housed the Café Victoria, which it remained until 1974, when Boots took over and applied for permission to alter and extend. In 1975, as work was progressing, the front became unstable and it was demolished, with just these few timbers being preserved – a forlorn reminder of the building's past. Inside Boots, just by the right-hand door, is a stained-glass panel showing the coat of arms of Ripon, rescued from the café.

4. Temperance, Drama and Bathing

Along Kirkgate

From the formality of the Market Square the main streets in Ripon's medieval core spread out in an irregular mesh to the north of the River Skell. Between the square and the cathedral is, historically, the most important street: Kirkgate, 'the street leading to the church'. Leaving the square, it initially plunges steeply down the slope of the glacial mound deposited when the Wensleydale glacier, higher up what is now the valley of the River Ure, melted at the end of the last Ice Age – 12,000 years ago.

This top section of Kirkgate is busy with traffic, but a feature worth noticing on the left as you go down the hill is Ripon's only significant art deco frontage, with its curve-ended and grooved lintels over the upper windows. This was, as the entrance suggests, one of Ripon's cinemas. It opened in March 1916 as the Picture Palladium, when it boasted 'an efficient ladies' orchestra' to accompany the silent films. The building, which incorporates earlier structures, was given its current style in time for a mayoral reopening in October 1936. It closed as a cinema in 1982 and served for some time as a nightclub.

Kirkgate curves gradually to reveal the cathedral's west front.

Kirkgate has some good Victorian shopfronts. A number of them, like Hornsey's Gallery opposite the former cinema, have a special Ripon characteristic: semicircular heads to the ground-floor display windows. Kirkgate bends left, towards the cathedral; the right-hand fork is Duck Hill. Halfway down Duck Hill, on the right, is a collection of small shops occupying what was originally, as the plaque in its pediment proclaims, a Temperance Hall. Funded in part by a local lace merchant, it opened on 21 November 1859 with, appropriately, a public tea.

On the opposite side of Duck Hill, at the foot of the railed steps, is the entrance to the lockup built by the council in 1838. From 1836 the council had been denied use of the Town Hall by its owner, Mrs Lawrence, great-granddaughter of William Aislabie of Studley Royal, because its members were mainly Whigs in opposition to her Tory views. The councillors rented the building above the lockup as council premises and as the borough police station. Lewis Carroll's youngest brother Edwin Dodgson was appointed a special constable in 1868 and would have known the building well. The council returned to the Town Hall in 1852, but the police stayed in Kirkgate until 1887, when the police station moved to St Marygate – the building there is now the Prison and Police Museum (*see* page 70).

As you walk further along Kirkgate its curve gradually reveals the majestic west front of the cathedral. Look out on the right, opposite the gateway that once led to

Above left: The entrance to the subterranean lock-up on Duck Hill.

Above right: Peacock's Passage leads off Kirkgate and was once gas-lit.

the Archbishop of York's palace, for an opening signed Peacock's Passage – another of Ripon's many ginnels or snickets. On the walls of the buildings at each side of the passage entrance are timbers among the plaster – a reminder that these Georgian and Victorian fronts hide more-ancient structures. Overhead are hooks and the remains of an early Ripon lighting scheme, with T-shaped gas pipes that once illuminated this shaded place.

DID YOU KNOW?
Visit Kirkgate on the morning of Shrove Tuesday and you'll probably encounter the Ripon Pancake Races. In a tradition said to go back 600 (or possibly 700) years, a bell in the cathedral tower is rung at 11 a.m. This 'Pancake Bell' heralds to the start of the recently revived races, which see clergy and civic leaders, children and business people race along the street in a charity fundraising event. The races created national headlines in 2008 when they were cancelled for 'health and safety' reasons. With a second look at the problem, the races were reinstated the following year.

Heading South

From the south-western corner of the Market Square, just by the Wakeman's House, another street descends the glacial slope: High Skellgate. Now greatly clogged with traffic, it leads from the city centre to Borrage Bridge over the River Skell (though it was originally down to a ford). Near the top, on the eastern side, is the former Church Institute, now Saks hair salon. It was designed by Tom Wall, who was architect and surveyor to the Studley Royal estate, which also had its Ripon office on this site. The Institute was the church's riposte to the secular Mechanics' Institute, housed in the building in Finkle Street that now hosts the post office (*see* page 64). It formerly met in what is now the Mayor's Parlour of the Town Hall.

The bottom of High Skellgate was once crossed by a mill race that wound along Water Skellgate, giving it its name. High Skellgate continues south, now as Low Skellgate. At the corner of Low and Water Skellgate is what was built as Public Rooms, now Sigma Antiques. Originally constructed in 1832, it was enlarged with a new 1,000-seat hall at the rear in 1885. In 1908 it was renamed the Victoria Opera House, but opera performances were few, as the following year it became a roller-skating rink. A cinema during the First World War and afterwards, it was later used for bingo, functions and for some amateur dramatic performances. In 1976 it was gutted by fire and is still not fully restored.

On the opposite corner is the Masonic Hall, which opened in 1903 and was used by the De Grey and Ripon Lodge (founded in 1860). Over the doorway are the square and compasses in stained glass, along with the Lodge number: 837. It is often open on heritage open days, when visitors can see the Temple, with its chequerboard floor, and the

Left: Sak's hair salon was formerly Ripon's Church Institute reading rooms.

Below: Sigma Antiques, formerly the Public Rooms and Victoria Opera House.

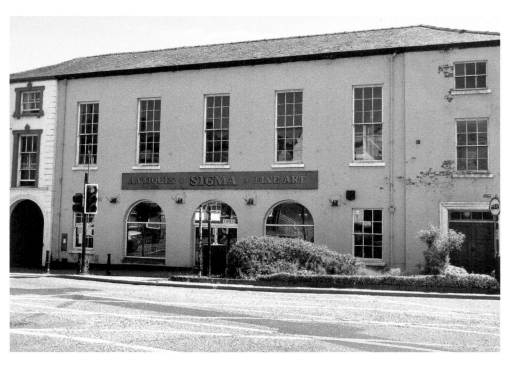

Masonic regalia of the Marquess of Ripon; the Marquess was Grand Master of the United Grand Lodge of England until his unexpected and controversial conversion to Roman Catholicism in 1874.

A little way along Water Skellgate is an ornate, red-brick structure that was most recently the Ripon City Club but began life as the school known as Jepson's Hospital. From the late seventeenth century until 1927 the boys of Jepson's Hospital in their blue coats lined with yellow, and blue caps, breeches and doublets, would have been a familiar sight in Ripon. The hospital was founded under the will of Riponian Zacharias Jepson. The boys were taught to read and write, and had to attend church each Sunday and Holy Day. Clever boys could be helped to attend Cambridge University; others would be apprenticed to Ripon tradesmen.

The original building was replaced by the present one in 1878. The architect was Mr Bishop of Ripon and the foundation stone was laid by the Marchioness of Ripon. Declining numbers of boys and falling donations forced the school's closure in 1927, with the boys going to the Grammar School. The hospital buildings were taken over by the Ripon City Club, but it no longer meets here, and the buildings are to be converted for residential use.

Low Skellgate has some attractive Georgian doorcases, but the queuing traffic makes them hard to appreciate. At the southern end, overlooking Borrage Bridge, are the former offices of the varnish makers T. & R. Williamson. As the ornate lettering proudly proclaims, Williamson's was founded in 1775 and the new offices were opened in 1925. The firm's founder, Daniel Williamson, had learned the secrets of varnish making from a French émigré. Soon four rival varnish manufacturers opened in Ripon, making the city the country's leading supplier. Only Williamson's survives, the oldest varnish house in the UK; it now makes surface finishes and paints in modern premises on Stonebridgegate.

The former offices of varnish makers T. & R. Williamson.

The Yorkshire Varnish Co., another of the city's varnish makers.

Borrage Bridge was originally constructed to allow the townspeople to access Borrage Green – Borrage is from 'burgage', the strips of land that were held by the townspeople – south of the river. It was rebuilt in 1765 to link with the new turnpike road from Leeds to Thirsk, which passed through Ripon, and was widened in 1885. Leading east from the end of the bridge is Barefoot Street – a corruption of Berford, meaning 'barley ford', indicating where the river was originally crossed.

Following Westgate

The approach to Ripon from the west brought country people into the Market Square along Westgate. They needed accommodation for their horses and drink to slake their thirst, so it is not surprising that Westgate had more than its fair share of pubs: in 1826 there were five in this short stretch, of which only one, the Black Swan, remains.

The Victorian shopfronts along Westgate, some with bay windows at first-floor level, repay close attention, but the most impressive of the buildings on the street is the early nineteenth-century house now occupied by Eccles Hedon solicitors. Built as a private house, it still retains its front area and railings; plans put forward in 1902 to remove them and widen the whole of Westgate were thwarted by the owner, Dr Collier, who refused all offers for this strip of land.

Many of the smaller premises at the far end of the street retain timbered frames under the plaster. Beyond is Calvert's Carpets showroom, which was built as the Ripon

Right: The eighteenth-century town house in Westgate, now occupied by solicitors.

Below: The remains of Samuel Butler's Theatre Royal, which opened in 1792.

Climber the Revd
Charles Hudson died
after conquering the
Matterhorn.

Cooperative Society store on the site of the former Black Horse pub and opened in February 1906. The roof still sports its original ventilation cowls.

Attached to its west end is a white-painted structure. The Ripon Civic Society plaque tells of its history as the remaining part of the city's Theatre Royal. Master-minded by actor and impresario Samuel Butler, the theatre opened on 20 August 1792, with 320 seats ranged in boxes along each side and benches on the main floor. Butler's touring company included the famous Shakespearean actor Edmund Keane. The parents of another celebrated nineteenth-century actor, George Bennett, was also part of Butler's company, and they were in Ripon when George was born in 1800, at a house just up the road in Park Street. After Butler's death in 1812 his son kept the theatre going for a while, but it closed in 1829. The building then became a military riding school and a drill hall, before spending much of the second half of the twentieth century as a garage for the United bus company. After a short time as a games venue, it was incorporated into the adjacent carpet store.

Park Street was also the birthplace of one of the men who first made it to the top of the Matterhorn. Charles Hudson, born in 1827, became a clergyman and one of the most noted alpine climbers of the mid-nineteenth century. In 1865 he was in a group of eight, which also included Edward Whymper, that made the first ascent of the Matterhorn. On the descent, tragedy struck: one of them slipped, and five men, including Hudson, fell to their deaths. The body of one was never found; the others, including Hudson, are buried in Zermatt.

5. Trying Out the Spa

Throughout most of the nineteenth century Ripon had envied Harrogate its cachet as a spa town. The long rivalry between the two settlements (which has not waned since local government reorganisation in 1974 when Ripon came under the control of Harrogate Borough Council) led at the start of the twentieth century to Ripon's determination to have its own spa. An incentive was given by the approaching tercentenary of the charter given to Ripon by James I in 1604.

Although there were some trickles of spa water in the city – there was a spa well on Stonebridgegate and St Wilfrid's Well on Skellgarths still has water that was once said to cure both eye troubles and the twisted legs of children with Blount's Disease – that wasn't enough to feed a fully functioning spa. There was, however, a good supply at Aldfield, 4 miles west of the city. It was decided to pipe the sulphurous water from there, but there were long and heated debates in the council before agreement was reached and the building was constructed to designs by Samuel Stead.

It was the last spa to open in England and the only one to be granted a royal opening – by Princess Henry of Battenberg, Queen Victoria's youngest child, Beatrice. It took place on 24 October 1905. With Princess Henry was her daughter Princess Ena, who the following year married Alphonso XIII of Spain, narrowly escaping death from a bomb on her wedding day. Princess Henry unlocked the doors with a gold key and then inspected the interior.

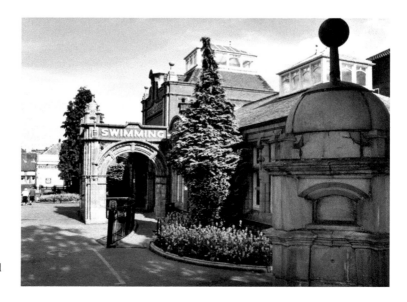

Ripon's Spa Baths opened to try to rival nearby Harrogate.

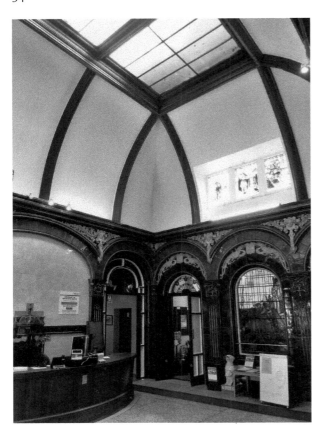

The pump room of the Spa Baths,
with Burmantofts tiles.

The main room inside is the former pump room, with stained glass showing the presentation of a horn by King Alfred to Ripon, and James I giving the 1604 charter. The basin from which the spa water was dispensed is behind the baths' pay desk, and, like the elaborate tile-work on the walls, was provided by the Burmantofts factory in Leeds. Elsewhere in the original building are art nouveau tiles, many of them now covered. In its first years of operation local people could have Ripon Spa water delivered each day (except Sunday) for a shilling a week. If they went to the spa in person, a glass, whether hot or cold, cost Ripon citizens a penny; non-residents paid a halfpenny for cold water and 2d for warm.

When the spa failed in the late 1920s a new brick structure was built at the back to house a swimming pool, and the complex has been used for that purpose since the 1930s. At the time of writing a new pool for the city is planned for a site beside the leisure centre to the south-west of the city centre; this raises the question of the future of the current building.

The Marquess of Ripon gave the land for not just the Spa Baths but for the adjacent Spa Gardens, the Spa Park and what is now the Spa Hotel, well known for its croquet lawns. The hotel was formerly the Hydro and was based on a large house called Elmscroft. The house was the birthplace in 1855 of the botanist Frederick Orpen Bower, who was professor of botany at the University of Glasgow. He was a fellow of the Royal Society

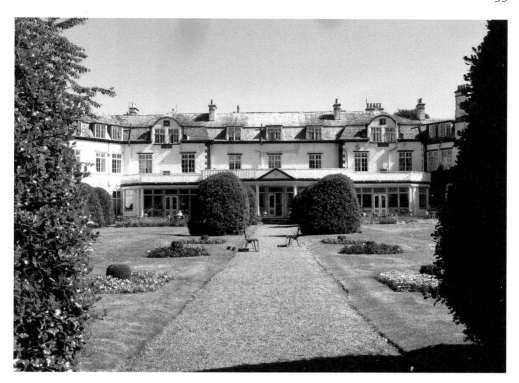

Above: The Spa Hotel, formerly the Hydro.

Right: The Marquess of Ripon at the entrance to the Spa Gardens.

and in 1930 president of the British Association. After a distinguished career he retired to Ripon, living until the age of ninety-two at the Old Deanery Hotel.

The Spa Gardens were laid out in 1902 and the bandstand dates from the following year. Greeting visitors as they enter the gardens is a statue of the marquess in his robes of the Order of the Garter. The statue is by the sculptor F. Derwent Wood and was unveiled in 1912, three years after the marquess's death. It's worth reading the back of the plinth, which lists his official positions, including Secretary of State for War and for India, First Lord of the Admiralty, Lord Privy Seal, Viceroy of India – and Mayor of Ripon. An identical statue stands in the Indian city of Chennai, formerly Madras.

There's more sculpture to see in the gardens. As well as the nearby war memorial, with the helmeted head of a First World War soldier in its summit, the stumps of a large tree near the bandstand have been imaginatively carved into the shapes of characters from Lewis Carroll's 'Alice' books, among them Alice herself, the Mad Hatter, the White Rabbit and the Caterpillar.

Across the road from the Spa Gardens is the grassed space of the Spa Park. Cut in its surface is a maze. It is a recreation of the original Ripon Maze that was once located on what was then Ripon Common, half a mile north-west of the park, near the junction of Palace Road and Little Studley Road. The original was almost 20 yards (18 and a quarter metres) wide and the winding path from the edge to the centre was more than 407 yards (372 metres) long. It was ploughed up when the common was enclosed in 1827. The Spa

Tree stumps carved with characters from Lewis Carroll's 'Alice' books.

The recreated Ripon maze in the Spa Park.

Gardens maze was dug by the Rotary Club of Ripon Rowels to mark the Golden Jubilee of Elizabeth II in 2002.

Nearby is the now-dry Severs Fountain, which once stood near the southern end of North Bridge, at the junction with Magdalen's Road. Put in place in 1875, it was described as 'a work at once useful and ornamental'. Given by John Severs at a cost of £130, it provided drinking water both for people and cattle. It was once finely carved with naturalistic leaves and berries as well as animals including frogs and lizards. It was moved to the Spa Park in 1929 and has suffered neglect and vandalism since.

Beyond the Spa Park, Park Street forks: the left branch becomes Studley Road and the right Clotherholme Road. The terracotta-topped walling that was seen alongside the Spa Gardens and by the Spa Hotel continues beside the road as it passes the rugby, football and cricket pitches.

Near the start of Clotherholme Road (Clotherholme was a village, long deserted, a couple of miles from the centre of Ripon) is a large house called Clova, most recently a residential home. From 1888 to 1900 it was occupied by eminent scientist and eccentric Charles Piazzi Smyth. Astronomer Royal for Scotland for forty-three years from the age of twenty-six, he was the first to put a telescope on a mountaintop, undertook important research in spectroscopy and meteorology and was a pioneer in photography; however, he was also convinced that the measurements Great Pyramid of Egypt held all the secrets of the universe. Mocked the scientific establishment for

Pyramid to Piazzi Smyth,
scientist and 'pyramidiot',
in Sharow churchyard.

his pyramidology (he was dubbed a 'pyramidiot') he retired to Ripon. He and his wife are buried in Sharow churchyard across the river from Ripon – appropriately under a pyramid-shaped tomb.

Schools and the Army

Further along Clotherholme Road, two schools face each other: the Grammar School and what is now Outwood Academy. The academy was opened in 1939 as Ripon Modern School; subsequent names were Ripon Secondary Modern School, Ripon City School and Ripon College. The Grammar School has much older origins. It is said to have been founded in the seventh century by St Wilfrid (with St Willibrord as one of its pupils); it was certainly in existence in the fourteenth century.

It was refounded in 1555; a copy of the charter of this date, issued in the names of Queen Mary and her husband, Phillip II of Spain, is on display in the school. Located near the cathedral until 1873 (*see* page 29), the school moved into a late Georgian house formerly occupied by Bishopton Close School, which had closed. New buildings were added in 1887–89 to designs by George Corson, who also designed the Victoria Clock Tower (*see* page 77). The school's own distinctive clock tower caused controversy; the Charity Commissioners objected to using endowments to pay for it, so it had to be funded

Ripon Grammar School – the original house (left) and 1880s extension.

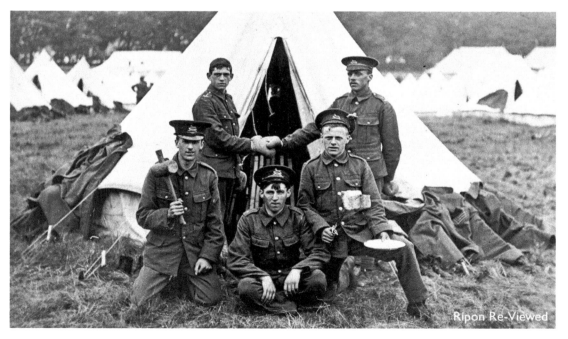

West Riding Regiment soldiers at Ripon army camp, First World War. (Courtesy of Ripon Re-Viewed)

by old boys of the school. The new buildings were opened by the Marquess of Ripon, chairman of governors, and the clock was started by the marchioness.

At the end of Clotherholme Road is Ripon Army Camp. There are two barracks – Claro and Deverell – which are all that remain of the once-vast camp, begun late in 1914 and in four months growing into a huge garrison accommodating 30,000 troops. They occupied a huge sweep of land to the north and west of the city. There were two main ones: North Camp, the headquarters for all army activities in the area, and South Camp, between the Harrogate Road (A61) and Studley Roger, which became known as 'Remount Camp' because it also accommodated a hundred horses used to train cavalry. There was also a hutted camp at Ure Bank and another alongside the Boroughbridge Road on land now occupied by the racecourse, which was the Headquarters of 76 Squadron of the Royal Flying Corps. Most troops and supplies were brought into the camp on a specially constructed narrow-gauge railway that connected to the Harrogate to Ripon line at Littlethorpe. During the course of the First World War 350,000 men passed through Ripon Camp. It had recreation huts, places of worship, a post office and a cinema, as well as a power station and a huge military hospital. The poet Wilfred Owen (*see* page 90) and the novelist and playwright J. B. Priestley both spent time convalescing at Ripon. 'There I was miserable, like everyone else I knew,' Priestley wrote later. Virtually all the camp was demolished in 1922; some of the First World War huts have survived in Deverell Barracks. Both Claro and Deverell Barracks are scheduled for final closure in the next few years.

DID YOU KNOW?
Ripon Grammar School is one of very few institutions to have a motto in Anglo-Saxon. It reads '*Giorne ymb lare ymb diowatdomas*' and translates as 'Eager to work and to serve God'.

The Hidden Gazebo

Returning down Clotherholme Road into Park Street, turning left by the tennis courts takes you along the side of the Spa Park. At the far end of the park, near the children's playground, you can just get a glimpse of one of Ripon's major secrets: the Grade II-listed gazebo. The tops of two brick towers with stone dressings and pantile roofs towers are visible; they are linked by a gallery walkway with a distinctive back wall of semicircles. The structure was built as a garden ornament, probably around 1719, by the Baynes family, who from 1679 until 1791 owned a large house in Park Street, then on the western edge of the city. The gazebo was a place from which to admire the garden below. From the gallery you could also look outwards into the countryside – then considered wild and untamed, but pretty to look at from the safety of your own garden.

The gazebo was derelict by the twentieth century and its ownership split. It took a Compulsory Purchase Order to enable Harrogate Borough Council to undertake repairs.

The gallery of the gazebo off
Blossomgate.

Since its restoration the gazebo has been virtually surrounded by sheltered housing;
originally it was possible to go through the buildings to see the gazebo, but in these
more safety-conscious days that's no longer possible. The gazebo is now usually open for
Heritage Open Days.

At the end of Church Lane is Holy Trinity Church, designed by Thomas Taylor of Leeds
and opened in 1827. It was built at the expense of a local doctor, Thomas Kilvington, who
left £13,000 in his will. Its interior has been reordered but retains its impressive plaster
ceiling. The church's original galleries were removed in the 1980s and a new one was put
up at the beginning of the twenty-first century. In contrast to the stone exterior, the crypt,

Above: The spire of Holy Trinity Church, one of Ripon's landmarks.

Left: Historian John Walbran, who lived opposite Holy Trinity Church.

The 'King Billy' pub in Blossomgate.

now cleaned and in constant use for church and other purposes, is brick, with impressive curved vaults.

On the corner of Blossomgate and Trinity Lane, opposite Holy Trinity Church, was the home of one of Ripon's historians, John Richard Walbran. Born in 1817, he worked as a wine merchant in Ripon but he was fascinated by the past and devoted as much time as possible to his studies. His best-known work, the *Guide to Ripon, Fountains Abbey, Harrogate, Bolton Abbey and Several Places of Interest in their Vicinity* first appeared anonymously in 1837, when he was nineteen, and was quickly reprinted in many, ever-expanded, editions.

In 1848 the Earl de Grey invited Walbran to supervise work on clearing the detritus of centuries at the ruins of Fountains Abbey; great heaps of spoil were removed using a small railway. Much of what we know of Fountains Abbey today – and quite a lot of what we can see – is due to Walbran's diligent and, for their time, careful excavations over several years. When he died in 1869 he was buried in the churchyard opposite his house – rather ironically, perhaps, because in the *Guide* he had described Holy Trinity Church as 'designed by the late Mr Thomas Taylor, whose successful practice should have suggested something better than this incongruous compilation'.

From Walbran's house, Blossomgate (the street of the 'plox-swain', or ploughboy) takes you back, via the end of Marshall Way to the end of Westgate. On the way it's worth glancing at the King William IV pub (the King Billy, as it's usually known), which has an Edwardian façade of brick and green-glazed tiles, and with stained glass proclaiming 'Vaults' and 'Smoke Room' at each side of an elaborate doorway.

6. Dissenters and Paupers

Leaving the north-east corner of the Market Square by Queen Street you will reach Old Market Place – now busy with traffic but formerly used for smaller markets – a wool market used to be held here in the early nineteenth century in an unsuccessful attempt to revive an earlier trade. In the fourteenth century Ripon had been Yorkshire's main producer of woollen cloth, exporting to the Continent though the east coast port of Hull.

The cloth trade had declined by the sixteenth century; in the seventeenth and eighteenth centuries the city was best known for its spur making, and especially for the rowels – the star-pointed wheels the spurs held to prick the horse. Ripon rowels were nationally famous and were mentioned by Ben Jonson in his 1625 play *The Staple of News*. They became proverbial; a man could be described as being 'As true steel as Ripon rowels'. A contemporary of Jonson's noted 'Rippon [the old spelling] in this county is a town famous for the best spurs in England, whose rowels may be enforced to strike through a shilling, and will break sooner than bow.'

Facing down Queen Street is one of Ripon's oldest inns, known for several centuries as the Black Bull but in the twenty-first century renamed the SO! Bar. On its east side is Finkle Street. Finkle means 'crooked'. The main building on the street is now Ripon's main post office, but it began its life as the Mechanics' Institute.

Ripon's main post office, built as the Mechanics' Institute.

The institute was founded in 1831. Its prime movers were the Williamson brothers, paint and varnish manufacturers. They were liberals and Wesleyans, so perhaps it was not surprising that they were viewed with suspicion by the establishment. The Institute was seen as a place of opposition to the Church of England and to the influence of the aristocracy who lived at Studley Royal nearby. It was only in 1845, when Ripon's Mechanics' Institute opened a literary society, that it gained some respectability – literature was so much more acceptable than practical science. In 1847 the cathedral's dean, Dr Erskine, decided to work with rather than oppose the Mechanics' Institute. After some years in hired premises, Ripon Mechanics' Institute had its own building in Water Skellgate. Then, in January 1893, tenders were accepted for the new structure on Finkle Street, at a cost of £1,079. The institute survived until 1927. The end was not dramatic; it was said to have 'quietly faded away'. The Finkle Street building was then occupied by HM Customs and Excise before, in 1957, being taken over by the Post Office in place of the former office on North Street.

DID YOU KNOW?
While the Mechanics' Institute was being built there was a dramatic incident; when workmen were connecting a gas supply from the Black Bull Hotel, there was an escape. In trying to stop it, they refilled the trench they had dug. The gas backed up into the pub's cellars and exploded, wrecking the dining room above.

Dissenters and Paupers

Opposite the far end of Finkle Street, to the right of the 1960s BT depot, is the entrance to the Temple Garden. This tranquil place, now full of trees and flowers around the central wrought-iron gazebo, was once the site of a chapel for the local Calvinistic Dissenters – which explains the gravestones along the sides of the path.

The foundation stone of the chapel, which went by the name of 'The Temple', was laid in May 1818 by the West Riding Home Missionary Society. It opened in September and held 420 people; in 1851 it was reported: 'There are 172 sittings let. Some that are poor take one sitting and occupy two or three; others pay for more than they occupy. The services produce on a deeply-attentive audience such impressions as the pious mind would wish to perpetuate.'

In 1871 the congregation moved to a new church (since demolished) on North Street. The Temple was pulled down, after serving for some time as a bonded warehouse for whisky and wines ('exchanging one sort of spirit for another', the wags said), and the area became derelict. In 1919 a correspondent to the *Ripon Gazette* complained about its state, and in 1932 unemployed men were drafted in to tidy it up. In 1973 British Telecom sought permission to extend its buildings on to what by now was known as the Dissenters' Graveyard, but this was refused. In 1986 Ripon commemorated 1,100 years since its charter from King Alfred in 866. As part of the celebrations the graveyard was laid out as a garden and named the Temple Garden (or sometimes Gardens, as the sign announces).

Gravestones in Temple Garden where a chapel once stood.

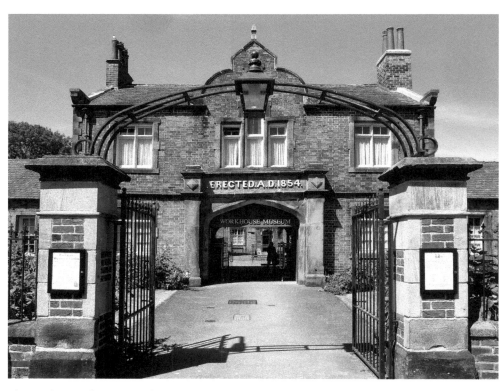

The gatehouse of Ripon Workhouse.

Adjoining the Temple Garden to the east is one of Ripon's main attractions. Unlikely as it may seem, this is the workhouse. In the nineteenth century, admission to the workhouse, for children as well as adults, was the last resort for people who had hit hard times. Even well into the twentieth century the workhouse was a place of fear; even when, like Ripon's, they had been converted into old people's homes, there was still general reluctance to take up places. It was felt that going into workhouse was an ineradicable stigma. Part of the Ripon Workhouse complex was opened in 1996 by the Ripon Museum Trust as the Workhouse Museum.

You enter the building by the gatehouse on Allhallowgate, built, as the date on it proudly proclaims, in 1854, to designs by Perkin and Backhouse, leading mid-nineteenth-century institutional architects of the West Riding. The room above the gateway is the Guardians' Room, where the board of guardians of the Ripon Union met to run the workhouse. They were the great and good of the area; the Marquess of Ripon, whose statue is in the Spa Gardens, was twice chairman of the board.

This gatehouse block also housed baths area, cells for male vagrants and the 'Receiving Wards' for inmates – men to the right and women to the left. Their garments and possessions were removed and, after they had been bathed, clothed in workhouse clothes and processed, they passed through the gateway to the main block. They knew they were destined for a harsh regime of discipline and work.

The central block of the workhouse, with its imposing front of Dutch-style gables, looks attractive. This was not for the inmates, however; it was where the master of the workhouse and the matron lived. The poor were confined to the segregated wings and there were separate quarters for children. The grandmother, mother, uncle and aunt of the novelist Barbara Taylor Bradford were among the workhouse inmates at the start of the

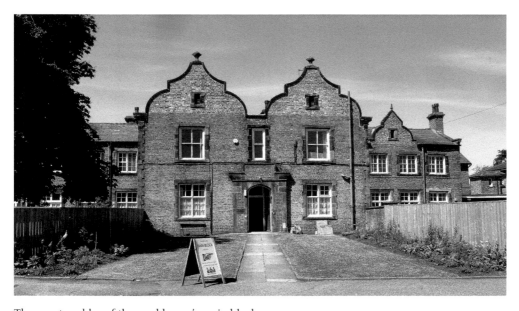

The ornate gables of the workhouse's main block.

The master's sitting room, as reconstructed by Ripon Museum Trust.

twentieth century. To the east is the block that from 1899 was the workhouse infirmary. Unlike the rest of the site, which is now in the care of Ripon Museum Trust, the infirmary is used by local community organisations.

The workhouse functioned as an old people's home from the 1930s until 1974, after which the main block was used as offices until 2016; it has now become an integral part of the museum. The master's house has been partly furnished in the style of the early twentieth century and the rest of the utilitarian structure is being developed as part of the workhouse experience.

Hidden behind the main block is the workhouse garden, in which the inmates would have worked and which provided produce for the kitchen. The garden has been laid out following the original plans and planted with nineteenth-century varieties of vegetables – including the 'Fellside Hero' potato, originally grown by a Northumberland gardener before being taken to Lincolnshire and successfully marketed as the 'King Edward' variety from 1902, the year of Edward VII's coronation. Produce from the garden is used by a local restaurant.

The Gas Lamp and the Cells

Allhallowgate gets its name from the former church of All Hallows (or All Saints), that probably stood near the bottom of the hill. It had certainly vanished by 1530, and probably earlier. The whole street was once lined with cottages like those on the left as you descend

Webb's patent sewer gas
lamp in Victoria Grove.

the hill. In Victoria Grove, which meets Allhallowgate on the right, is another of Ripon's
curiosities, a Victorian sewer-gas lamp. Moulded into the base are the words 'J E WEBB'S
PATENT GAS SEWER DESTRUCTOR'. Webb perfected a way of raising the heat of the
burning gas jets to around 400 degrees centigrade; the heat drew up the noxious gases of
the sewers below, ensuing their regular dispersion. Contrary to popular belief, the sewer
gases were not burned to make the light. The lamp is Grade II listed; it is a pity its fine
fluted column has been marred with a parking sign.

At the foot of the hill Allhallowgate meets one of the oldest of Ripon's thoroughfares.
To the left is St Marygate; there was once a chapel dedicated to Our Lady – the 'Ladykirk' –
on the street. On the corner is a white-painted house that was once the Fleece Inn. Behind
it is Allhallows Park, a quiet place with play equipment for children and seats. This was
formerly a derelict area of spoil heaps from clay pits and was turned into a park by Ripon
Civic Society; it is now cared for by Harrogate Borough Council.

On St Marygate, opposite the entrance to the park, is a large house with a mosaic
plaque advertising 'W F M Blackburn, Builder'. His showroom was in the large-windowed
room to the right of the door. The row of small cottages to the south brings us to the

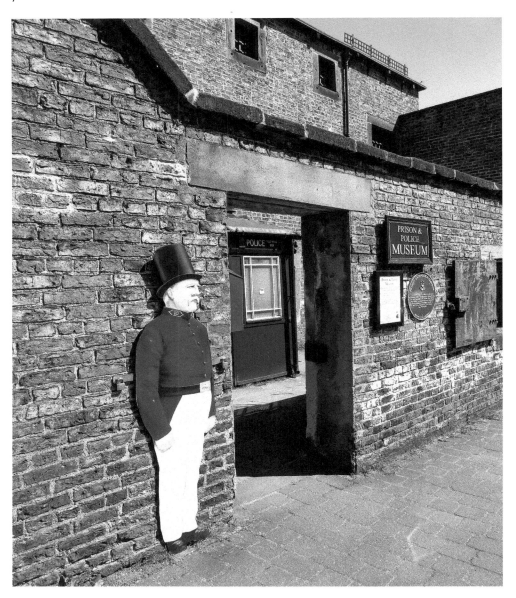

The Prison and Police Museum was once Ripon's police station.

Prison and Police Museum. The imposing red-brick cell block was built in 1816 on the back of the House of Correction (see below). It contains cells for malefactors and is now run by the Ripon Museum Trust. It tells the story of policing from Anglo-Saxon times, through the formation of the professional police in 1829 to the modern force. You can see uniforms and headgear – and in the upstairs cells you can see and try some of the pointless punishments of earlier days, like the crank handle.

The royal arms and chains at the House of Correction.

The cell block had an aristocratic architect – Thomas Philip de Grey, 3rd Lord Grantham and, from 1833, 2nd Earl de Grey. His brother, Lord Goderich (later Earl of Ripon) was briefly prime minister and Goderich's son, born at No. 10 Downing Street during his father's short tenure, was the 1st Marquess of Ripon. The Prison and Police Museum building was one of Grantham's earlier architectural works, dating from 1816, when he was aged thirty; he later became first president of the newly founded Institute of British Architects.

Just beyond the museum is a doorway with the royal coat of arms over it and some real, fearsome-looking chains above. It was intended to strike fear into the hearts of the local ne'er-do-wells, as this was one of the entrances to the House of Correction.

On 31 March 1683, the minutes of Ripon City Council record it was 'ordered and agreed that the mayor and other justices of the peace for this corporation shall set up a workhouse and house of correction (for setting the poor here on work, and punishment of such as by law are there punishable) accordingly as they shall think fit'. As a result of this decision, the current building, which can be seen from Residence Lane just beyond, was erected in 1684. The House of Correction was a place to which beggars and vagrants were committed under the Poor Law Acts. Here, the Justices of the Peace could detain people of 'loose, idle and disorderly conduct', usually for no more than two weeks. When in the House they had to undertake some form of hard labour. The House of Correction, marked by a Ripon Civic Society green plaque, is now in private hands.

On the wall opposite the House of Correction is another plaque, detailing the location of the Celtic monastery (*see* Chapter 1). The area behind the wall was the site of the

The limekilns, now filled, found near Residence Lane.

former Residence (hence Residence Lane) used by the canons-in-residence of the nearby cathedral – including, from 1859, Lewis Carroll's father Archdeacon Dodgson. Across the road is a medieval wall, with an archway. This is Abbot Huby's Wall, built by the abbot of Fountains Abbey in the early sixteenth century.

Follow Residence Lane as it narrows; the new houses of Limekiln Cottages are on the site of a one of the largest medieval limekilns ever discovered in the country. Uncovered when a previous building on the site was demolished in 2009, the stone-lined kiln was almost 18 feet (5 and a half metres) wide at the top and 13 feet (4 metres) wide at the base, more than 7 feet (2 metres) below. It may have been used to burn lime to make mortar used in the rebuilding of cathedral's central tower after its collapse in 1450, and of the new aisles added to the nave in the 1500s. The kiln was recorded after excavation and then refilled.

Residence Lane comes out into Priest Lane, by the entrance to Ripon Cathedral Primary School. Turning left brings us back to the crossroads at the foot of Allhallowgate, but take a brief detour down Lickley Street to see the small plaque outside No. 17 that commemorates the street's winning the competition for best-decorated street in the city at the time of the 1953 coronation.

DID YOU KNOW?
There are two Ripons in the United States: Ripon in Font du Lac County north-west of Milwaukee, Wisconsin, where the Republican Party was founded; and Ripon in San Jaoquin County, California, the almond capital of the US. There's a Ripon in Northern Kerala, India, noted for its fine tea, and a Ripon district in Western Victoria, Australia. The Ripon Falls, one of the outlets of Lake Victoria, were named after the 1st Marquess of Ripon, but were lost when the lake was extended for a power station.

7. Saints and Woodbines

Stonebridgegate, which continues the line of St Marygate from the junction with Allhallowgate, largely follows the original main route through Ripon to the ford on the River Ure. It is now an unrewarding walk; the fire station and the Aldi store on the site of the former Ripon Gas Works are not architecturally exciting. Yet do persevere. The Magdalen's public house stands opposite the open area of Paddies Park, named from the Irish navvies who dug Ripon Canal in the late 1760s. The road now changes its name for a third time, to Magdalen's Road. It was behind the houses across the road from the Magdalen's pub that the sink hole appeared in 2016 (*see* Chapter 1).

Further along Magdalen's Road is the building that gave it its name – the Chapel of St Mary Magdalen. The building was founded about the year 1115 by Thurstan, Archbishop of York (a modern statue of him stands on the screen in Ripon Cathedral). It was administered by religious sisters and a chaplain, who had a duty to care for lepers, so it is often still known as the Leper Chapel. Only the chapel, mostly from the twelfth century, remains of the original hospital buildings that once stood around it.

Chapels like this were traditionally dedicated to St Mary Magdalen, a saint who was seen as an outcast welcomed by Christ. The sisters here fed and clothed the lepers, who were able to receive Mass. The low window on the north side is said to have been used for the priest to pass out the consecrated host to them. By the mid-fourteenth century leprosy was dying out, probably from an increased immunity, and the hospital and chapel then looked after the poor and sick of Ripon.

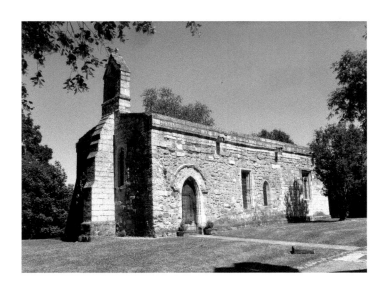

The chapel of St Mary Magdalen, or the Leper Chapel.

Inside are a Norman font, rescued from use as a cattle trough in a nearby field, a fifteenth-century wooden screen and two medieval wooden benches with carved finials. The altar is the original stone one, discarded and broken after the Reformation. In front of the altar is a mosaic panel said to be from a Roman villa excavated locally. There is also a wooden bell, supposedly put in place as a deception when a former master sold the original metal one.

The almshouses next to the chapel, designed in 1892 by John Oldrid Scott (son of Sir Gilbert Scott who restored the cathedral), and the earlier ones across the road, continue the charitable work begun by Thurstan. In 1878 a new chapel, to designs by William Henry Crossland, a pupil of Gilbert Scott, was built to serve the older almshouses. It is now a private house.

North of the ancient chapel is open ground that is affected by gypsum, and beyond is Ripon bypass. The road bends left by a row of Dutch-gabled houses (more modern houses behind them, along Magdalen's Close, picked up the style). The floodplain of the River Ure faces the terrace of houses, with the ancient North Bridge crossing the river to the Ure Bank area. The bridge is first mentioned in 1242. In the fifteenth century a chapel dedicated to St Sitha stood on it; Sitha was invoked as a protection against drowning.

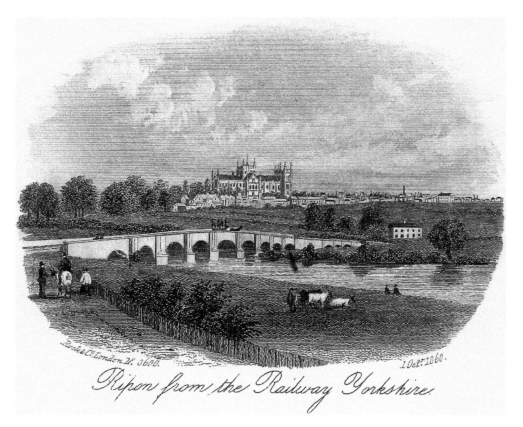

North Bridge in 1860, showing the small size of the city.

The railway viaduct formerly crossed the river near North Bridge. (Courtesy of Ripon Re-Viewed)

Parts of the bridge's medieval structure remain in its seven arches, but it has twice been widened on the upstream side. It has impressive stone spouts to drain water from the road surface. The river often floods here; there's an inscription on the west side of the bridge noting the height of the floods of 29 January 1883. Just to the north of the bridge was a place where boats could be hired, and where there were changing rooms (men only) for bathing in the river. Both the boating station and the bathing have long been abandoned.

Across the bridge is Ure Bank, where Ripon railway station was located. Ripon was joined to the railway network in 1848, with the line looping from what we now know as the East Coast Main Line near Thirsk, through Ripon to Harrogate and Leeds. There was a railway viaduct across the river, approximately on the line of the new bypass bridge. The first pile of the viaduct was laid on 22 March 1847, a red-letter day: 'the Minster bells

Caravans stand on the concrete footings of former POW huts.

rung, and there was much rejoicing.' The station was almost a mile to the north of the city centre. It closed in 1968 and the buildings have mostly been converted to housing. Higher up Ure Bank is the now-derelict former maltings, a huge brick building described as one of the most interesting surviving maltings in the country. It formerly served several Ripon breweries.

Beyond the maltings is a caravan park that in both world wars was an army camp and in the Second World War the site of Prisoner of War Camp 247 – the caravans and park homes today use the concrete foundations of some of the 101 huts as hardstanding.

DID YOU KNOW?
Until local government reorganisation in 1974, the River Ure was the boundary between the West Riding of Yorkshire, in which Ripon was located, and the North Riding; the West Riding authority was responsible to the upkeep of North Bridge.

Marking Time – and the Woodbines

Returning from North Bridge south towards the city centre, after Magdalen's Road is the former Station Inn, now privately owned. Throughout most of the twentieth century Ripon's auction market operated behind the inn. It closed after the national outbreak of foot and mouth disease in 2002. The area is one of the most prone to gypsum collapse.

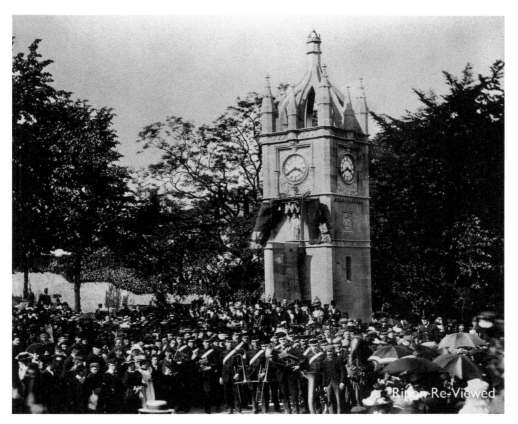

Crowds surrounded the Victoria Clock Tower at its opening in 1898. (Courtesy of Ripon Re-Viewed)

A little further up on the opposite side of North Road is Fremantle Terrace, named after Dr William Fremantle, Dean of Ripon from 1876 to 1895. His successor as dean was his nephew, also William Fremantle. The modern terrace of houses to its north has been confusingly been called Freemantle Place.

At the crossroads near the city centre is the Victoria Clock Tower. It stands halfway between the Market Square and the station, encouraging travellers to hurry to catch their trains. The tower was designed by Leeds-based Scottish architect George Corson (who also designed Ripon Grammar School – *see* page 58) and was the gift of Miss Frances Mary Cross and Miss Constance Cross, who lived at Coney Garth in Kirby Road, to celebrate Queen Victoria's Diamond Jubilee in 1897. The rather dumpy statue of the queen on the south side and the Gothic inscription are a Jubilee cheer. The tower was inaugurated on 28 June 1898 with great ceremonial, including a dedication by the Bishop of Ripon. As part of the celebrations the Misses Cross handed the Mayor of Ripon a deed of gift vesting it in the council, and the key the door that leads up to the clock's works.

The open area of trees and grass nearby was formerly known as Goose Green. Another area prone to gypsum subsidence, is it now cared for by Harrogate Borough Council as a small park, a favourite of dogwalkers. 'Ripon In Bloom' has provided picnic tables and signs, and planted a patch of wildflowers adjoining Princess Road.

Above: The former Ripon Clergy College occupied these houses.

Left: Geoffrey Studdert Kennedy – 'Woodbine Willie' – Ripon Clergy College student.

The red-brick Gothic-style terrace at the junction of Princess Road and North Street was once the home of Ripon Clergy College. Initiated in the same year that the Clock Tower was opened, it was founded by the Bishop of Ripon, William Boyd Carpenter, to be 'a training centre on modern and liberal lines for theological students desirous of entering the ministry'.

Its most illustrious student was Geoffrey Studdert Kennedy, the First World War chaplain known as 'Woodbine Willie', who was famous for his habit of giving the troops the Woodbine cigarettes that earned him his nickname. Born in Leeds, Kennedy studied at Trinity College, Dublin, before enrolling at Ripon Clergy College. He volunteered for the army in 1914 and was often in the thick of the fighting. He described his ministry as a chaplain as taking 'a box of fags in your haversack, and a great deal of love in your heart', and said, 'You can pray with them sometimes; but pray for them always.' He won the Military Cross in 1917 at Messines Ridge in Flanders after running into no man's land to help the wounded during an attack on the German frontline. After the War he became a prominent Christian Socialist and pacifist. Ripon Clergy College later moved to Oxford as Ripon Hall, a memorial to Bishop Boyd Carpenter, and is now known as Ripon College Cuddesdon. See if you can spot the error on the Civic Society's green plaque about the college!

Palace Road, which heads in the direction of Masham from the Clock Tower, has some of the city's most substantial houses, and eventually leads to the one that gave the road its name, the palace of the bishops of Ripon. Ripon diocese was established in 1836 out of the dioceses of York and Chester – the first new diocese since the Reformation. At the time there was no official residence for the first bishop, Dr Longley (later Archbishop of York and then of Canterbury), but on 1 October 1838 the Bishop laid the foundation stone for a new palace. It was designed by William Railton, who the following year won the competition to design a memorial to Nelson in London's Trafalgar Square – Nelson's Column. The new palace was described as 'a spacious stone building, [that] skilfully combines all the arrangements demanded by the comforts and elegancies of modern

A Victorian drawing of the Bishop's Palace.

times, with picturesque, but often intractable, detail of the Tudor era'. The bishop moved in in 1841 and six years later a chapel was added.

Some of the carvings on the outside of the chapel are said to have inspired Lewis Carroll, a regular visitor with his father, Archdeacon Dodgson. Carroll was friendly with the Bishop's children and for them he wrote *The Legend of Scotland*, a comic ghost story set in a room called Scotland in Auckland Castle, home of the Bishop of Durham. The archdeacon is commemorated by a stained-glass window in the chapel. The palace and chapel are privately owned and not open to the public.

Carroll's Friends

Returning to the Clock Tower and heading along North Street towards the city centre, look for the entrance to The Crescent on the right. This was one of the most prestigious places to live in Ripon, with large, Italianate villas around a central, tree-surrounded lawn. No. 2 was the home, in Lewis Carroll's time, of the Revd Canon Baines Badcock and his family. Carroll is said to have seen a photograph of Badcock's daughter Mary in a Ripon photographer's shop, and asked the canon's permission to send it to John Tenniel who was illustrating Carroll's 'Alice' books. Tenniel visited the Badcocks and his version of Alice does bear a strong resemblance to young Mary. At the other extreme, Carroll is said to have based the bad-tempered duchess on Mrs Badcock!

At the top, on the gatepost of No. 9, a Ripon Civic Society plaque marks more links with Lewis Carroll. He was a regular visitor to the Cunninghame family who lived here;

The Crescent – the Badcocks lived at No. 2 (left).

the Revd Hugh Cunnynghame was the chaplain to the House of Correction. The four Cunnynghame children – Margaret, Clara, John and Hugh – were Carroll's particular friends. He visited them in the first few weeks of the year and during his holidays from Oxford University, from 1852, when he was twenty, until 1868. On 30 January 1868 he wrote a letter in verse to Margaret – known as Maggie. It begins:

> I found that the 'friend'
> that the little girl asked me to write to,
> lived at Ripon and not at Land's End
> – a nice sort of place to invite to!
> It looked rather suspicious to me
> – and soon after, by dint of incessant
> enquiries, I found out that she
> was called 'Maggie' and lived in a 'Crescent'.

In a poem 'O Caledonian Maiden' he wrote about Clara's piano playing:

> I shall think of those half hours
> In Ripon spent with you;
> I shall dream of great Beethoven
> And of Mendelssohn so true.

In 2003 the garden at No. 9 The Crescent was redesigned for a BBC television programme called *Small Town Gardens*. Inspired by the Lewis Carroll associations, it was given playing-card-shaped flower beds planted with red and white roses, chequerboard paving and wrought-iron obelisks.

Higher up North Street is the White Horse pub with its bay windows, built in the early nineteenth century. It was originally called the Hat and Beaver – a reference to hats made of beaver felt (the maker was known as a 'beaver') – but changed its name between 1822 and 1824; it's probably co-incidence that there's a Beaver in *The Hunting of the Snark*. Opposite the pub is what is now North House Surgery but was once called Town House. It was intended to be the official residence of the Mayor of Ripon (a riposte to the Mansion Houses of London, York and Doncaster, perhaps) but never used for the purpose.

The traffic lights beyond are at the foot of Coltsgate Hill. In the first decade of the twenty-first century the new road called Marshall Way (named after Marshall's stone yard that was formerly here), was pushed through the area to provide traffic relief and open up mostly derelict land to the west of the Market Place. Successive demolitions at the junction have left a wide gap; some of the shops once here have a new life in the Castle Museum in York, where their façades were re-erected after removal.

The original character of Coltsgate Hill resumes a little way up, with old cottages lining the street. On the right is the former Coltsgate Hill Methodist Chapel. John Wesley, the founder of Methodism, originally found Ripon a godless place; nevertheless, the first

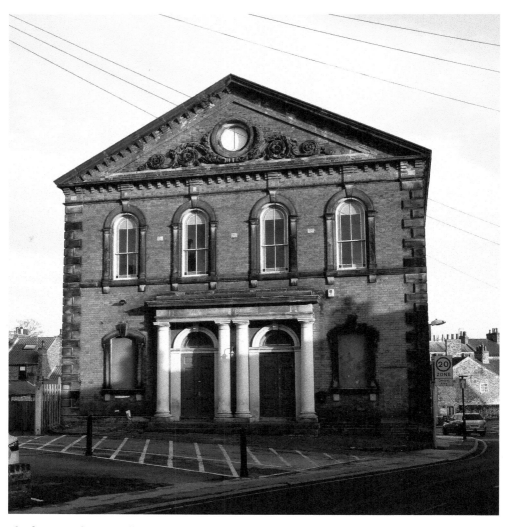

The former Coltsgate Hill Methodist Chapel, dating from 1861.

Wesleyan Chapel was established on this site in 1777. Wesley visited it in 1780 and this time noted its success:

> We came to Ripon, and observed a remarkable turn of Providence: the great hindrance of the work of God in this place has suddenly disappeared; and the poor people, being delivered from their fear, gladly flock together to hear His word. The new preaching-house was quickly more than filled. Surely some of them will not be forgetful hearers.

By the mid-nineteenth century a larger building was needed, and in 1861 the new chapel, designed by James Simpson of Leeds, was opened. Workmen preparing for the foundation stone had earlier discovered two bodies, at least a century old, of a woman of around

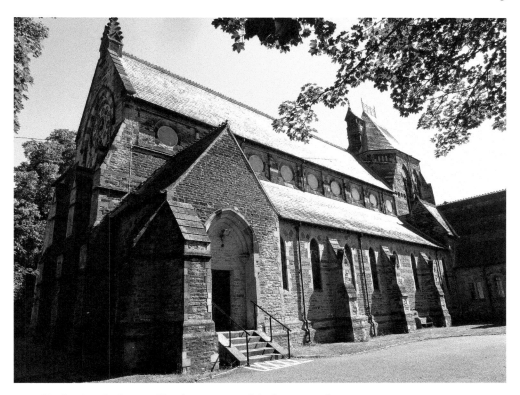

St Wilfrid's Church, designed by the inventor of the hansom cab.

twenty-five and man approximately twenty years older; they were suspected of having been murdered. The chapel closed for worship in 1962, though the interior until recently remained mostly intact. After use as a warehouse and offices, the future of the building is currently uncertain.

A little higher up, at the corner of Trinity Lane, is St Wilfrid's Roman Catholic Church. Opened in 1862, the church was designed by architect Joseph Hansom (inventor of the hansom cab) in French Gothic style; it must have seemed an oddly alien structure in a conservative place like Ripon. It has an unusual eastern tower that is one of the vertical accents of the city skyline, along with the cathedral, the obelisk and the spire of Holy Trinity Church. Inside, the tower sits over the sanctuary, providing a spectacular burst of light over the altar. It has an altarpiece by Edward Pugin, mosaics by the Italian Salviati company, stained glass by John Hungerford Pollen and fittings from the Marquess of Ripon's private chapel at the now-demolished Studley Royal House. After his controversial conversion to Catholicism in 1874 the marquess was one of the leading Catholic laymen in the country.

Feuds and Controversy

The narrow lane opposite the north side of St Wilfrid's Church is known locally as 'Killiecrankie' after the narrow pass in Scotland where a battle was fought between the Jacobites and government forces in 1689 – its official title is College Walk. In the

College Walk – usually known as Killicrankie.

The former Ripon Training College main building (now apartments).

nineteenth century it was used by gangs of boys in their feuds. In 1895 it was reported that 'a fracas occurred between the Grammar School boys and town boys ... stones were thrown to the danger of the public and the boys were charged with common nuisance.' The case was, however, dismissed.

Coltsgate Hill becomes College Road as the rise levels out. The wide expanses of lawn fringed with a row of mature trees once formed the foreground to Ripon Training College, founded in York in 1846 to train female teachers; it moved to Ripon in 1862. It was noted that 'the object of this Institution is to impart the necessary education to Candidates for the office of a Schoolmistress, with special reference to the wants of National Schools in the Dioceses of Ripon, Wakefield and York'. The buildings were designed by J. B. and W. Atkinson of York.

In 1974 the Ripon Institution combined with St John's College in York as the College (later University College) of Ripon and York St John. In 2001 the Ripon Campus was closed and sold, and the buildings, including the former chapel designed by John Oldrid Scott, have been converted to housing. At the east end of the former campus is the building of 1904 that for almost sixty years housed Ripon Girls' High School until it amalgamated with the boys' Grammar School on the Clotherholme Road site in 1962. It was later used as a lecture block for the college. At the time of writing it is derelict and its future is the subject of controversy.

Beyond the former College grounds, near the junction with Kirkby Road, is Ripon Cemetery, opened in 1892 and now augmented by a new cemetery nearby on Little

The attractive Smithson's Court, off North Street.

Harries Lane. A competition to design the gatehouse, chapel and entrance gates attracted twenty-six architectural practices, and was won by the London firm of Clark and Hutchinson, who provided the half-timbered lodge building more suited to Surrey than North Yorkshire. The council borrowed £5,273 to prepare and open the cemetery.

Returning to the traffic lights at the foot of Coltsgate Hill and turning right, you're in the southern part of North Street. Unlike many of the city's streets, this one is wide – its former name of Horsefair suggests why. On the right is the Curzon Cinema, formerly Abbott's furniture store. Ripon's answer to a multiplex, the Curzon has two screening rooms: the larger seating fifty-eight people; the smaller with thirty-eight seats. Just beyond the cinema is the entrance to the attractive Smithson's Court. For many years from the nineteenth century the butcher's shop at the corner was owned by the prominent Smithson family.

Opposite the Curzon, Baroque hair salon was once Ripon's post office. To its right are two shops – a barber and a florist – with an arch between them. These were the showrooms of the British Iron and Implement Works, run by the Kearsley family who also had one of Ripon's varnish works. The foundry was in Trinity Lane, near St Wilfrid's Church – that building is now occupied by NY Timber. The British Iron and Implement Works supplied all types of agricultural and gardening implements; one of their advertisements boasted that their 'PRIZE GRASS MOWERS Have been Supplied to the Estates of HIS MAJESTY THE KING and the BRITISH GOVERNMENT.'

DID YOU KNOW?
The Marquess of Ripon had an unrealised scheme to bring a tramway from the railway station, along North Street and out through Fishergate (around where The Original Factory Shop now is), and thence west of the Market Place to run along Studley Road towards his park at Studley Royal.

8. By the Waters

The River Skell threads through Ripon just south of the centre, and the River Ure runs to the north-east. Ripon's third river is the Laver, which joins the Skell to the west of the city centre in the area called High Cleugh. From the south-east corner of High Cleugh, Borrage Lane runs parallel with the Skell. The First World War poet Wilfred Owen stayed at No. 24 Borrage Lane. After time in hospital in Scotland for shell shock received on the Somme, he arrived in Ripon at what he called 'an awful camp' on 12 March 1918. His accommodation was in a hut that held fourteen officers – '13 too many', he said. He described his day: 'from noon to about 3.00pm we do physical, short walks and lectures. We are thus free all evening. I shall not know what to do unless I get a room where I can use my big spectacles to advantage.' He quickly found space in this cottage. 'It is a jolly retreat,' he wrote. 'There I have tea and contemplate the inwardness of war.'

From the cottage he could walk to the camp, following the river and contemplating his poems; it was while staying in Ripon he wrote 'The Send-Off', 'Mental Cases', 'Futility'

The war poet Wilfred Owen lived in this Borrage Lane cottage.

The 'Fairy Steps' by the River Skell.

and, probably, 'Strange Meeting'. In the cottage he drafted the famous preface to his war poems: 'My subject is war, and the pity of war. The poetry is in the pity.' He spent much of his twenty-fifth birthday – 8 March 1918 – in Ripon Cathedral. He rejoined his battalion at Amiens in September 1918, where he won the Military Cross. He was killed early in the morning of 4 November 1918 – just seven days before the Armistice ended the First World War.

Owen's route to the camp took him over a footbridge (the 'Rustic Bridge') across the Skell near High Cleugh. The army occupied much of the open common area around, and a flight of very shallow concrete steps with smooth sides gives access to the higher ground. These are known locally as the 'Fairy Steps' – a name that may have been bestowed because of the small footsteps that are needed to ascend. There are other explanations – all linked to the army: the steps seem to have been put in place, or at least adapted, as part of the camp, to enable the transport of guns to the common above.

If you turn left after crossing Rustic Bridge from High Cleugh you can follow the riverside path into Borrage Green Lane and go through the children's playground and under the bridge to continue alongside the river. After the new bridge at Williamson Drive, the next is Bondgate Bridge. The current iron structure was opened in 1892, but there has been a bridge across the Skell at this point since around 1100.

DID YOU KNOW?
For a few years Ripon was the most northerly point on the connected British canal system; that accolade remained until the opening of the Ribble Link on the Lancaster Canal in 2002.

Bondgate – Home to a Murderer?

You are now in Bondgate, in the past always viewed as a settlement separate from Ripon. In 1851 it was reported that the population of the Ripon portion of the city was 5,553 and Bondgate 527. Bondgate was traditionally the home to the city's saddletree makers, who provided the wooden structures for saddles. The famous convicted murderer Eugene Aram lived in Bondgate during his schooldays; his father was a gardener at Newby Hall. Eugene later became a teacher in Knaresborough, and in 1745 was accused of conniving with a friend, shoemaker Daniel Clarke, in the theft of goods; Clarke had by this time disappeared. In 1758 a body, identified as Clarke's, was found in a Knaresborough cave. Aram, then working as a schoolmaster in King's Lynn, was arrested and put in trial in York. Despite a spirited and learned defence, which he conducted himself, he was found guilty of murder and hanged – though doubt remains as to his guilt. His story became famous, being celebrated in a novel by Bulwer Lytton and a poem by Thomas Hood that ends:

> Two stern-faced men set out from Lynn,
> Through the cold and heavy mist;
> And Eugene Aram walked between,
> With gyves upon his wrist.

Next to Bondgate Bridge is the Chapel of St John, Bondgate, the third of Ripon's ancient chapels, along with St Anne's (*see* page 29) and St Mary Magdalen's (*see* page 73). Unlike them, however, this is a Victorian chapel designed in 1869 by W. H. Crossland (who was also the architect of the new St Mary Magdalen's). The bell in the bellcote is a survivor from the older chapel on the site. There are almshouses to the rear.

On the east side of the chapel is Bondgate Green, now a widening of the main road towards Boroughbridge but once an area of open land. Gateposts on its southern side lead to another of Ripon's secrets: its canal. Ripon Canal, supplied with water from the Skell

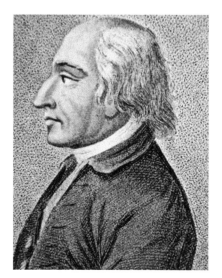

Eugene Aram, who lived in Bondgate, was executed for murder.

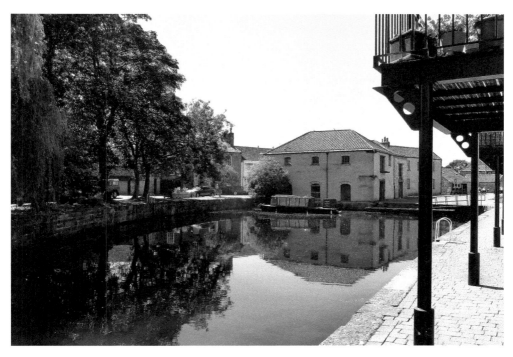

Ripon Canal basin now welcomes pleasure boats.

Lock House and Rhodesfield Lock on Ripon Canal.

and the Laver, is one of the shortest in the country – just 2 and a half miles (1 and a half kilometres). Authorised by Act of Parliament in 1767 at an estimated cost of £9,000, its purpose was to connect the city via the River Ure to the River Ouse and then the Humber, allowing goods – particularly coal – to be carried to Ripon and lead and agricultural products from the city's hinterland to reach distant markets. The engineer in charge of the new canal was John Smeaton, though the work was carried out under the supervision of Smeaton's pupil William Jessop. It was finished in early 1773, having cost £16,400.

In 1844 the Leeds & Thirsk Railway bought the canal and trade gradually diminished. In 1892 barge traffic ceased and by 1906 the canal was impassable. It was officially abandoned in 1956. The Ripon Canal Company was formed in 1961 to prevent the canal being filled in, and over the next twenty-five years the lower half was restored for navigation, but the upper part, to the canal basin, just beyond the impressive gateposts, remained derelict. The canal company's successor, the Ripon Canal Society, eventually organised the complete reopening in September 1996.

Now the canal welcomes pleasure boats. A little way down the canal is a small, white-painted building with Gothic-style windows – this is the sanitary station, constructed for the reopening. Its style is based on the lock house a few hundred yards beyond, where the canal bends to the first of three locks on the canal. After the second lock is the entrance to the 108-berth marina, usually crammed with boats. The Smeaton Centre offers facilities and information for canal users.

Racing for the Finish

If you follow the canal towpath you will soon find yourself alongside Ripon Racecourse – if it's a race day you might see the horses thundering round the 1-mile, 5-furlong (1.6-kilometre)

Ripon Racecourse – on this site since 1900.

flat racing track. The entrance to what's dubbed 'Yorkshire's Garden Racecourse' is on Boroughbridge Road. The first races were held on this site in 1900, though Ripon has held races since at least the seventeenth century in various locations, including Bondgate Green, Ure Bank, Ripon Common and at Whitcliffe Lane, where the former grandstand, later part of the now-closed Ripon Cathedral Choir School, still exists. The best-known race held on the present course is the 6-furlong (1.2-kilometre) sprint known as 'The Great St Wilfrid Handicap' after the city's saint. Much of the centre of the racecourse is taken up by a lake, usually thronged with birds, formed from the gravel extraction that is still taking place nearby.

In the First World War the southern half of the racecourse held a landing strip used by 76 Squadron the Royal Flying Corps (from 1918 the Royal Air Force), perhaps stationed here as a result of a Zeppelin raid over the Ripon area in October 1916, when bombs were dropped close to the city. The strip was also used for a short time after 1919 as a civilian aerodrome. On the eastern edge of the racecourse area are concreted areas to each side of the road. These were used in the Second World War for tank practice; the slope into the River Ure allowed them to cross and to rumble up the river.

Adjacent is Hewick Bridge, which carries the B6265 road over the Ure. The current bridge dates from the eighteenth century and has been widened on the upstream side, but there has been a crossing here for much longer. In the Middle Ages there was a chapel on the bridge and in 1697 the traveller Celia Fiennes noted that 'Hewet Bridge' was 'pretty large with several arches' but was 'often out of repaire by reason of the force of the water that swells after great rains, yet I see they made works of wood on purpose to break the violence of the Streame and the middle arche is very large and high.'

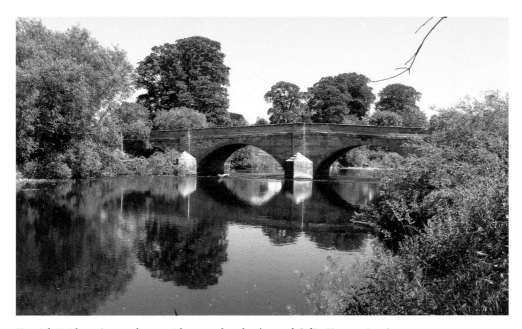

Hewick Bridge – 'pretty large with several arches', noted Celia Fiennes in 1697.

The footbridge and ford at Fisher Green.

It's possible to walk from Hewick Bridge back in to the city beside the Ure and then by the Skell, crossing on stepping stones to the north bank near Fisher Green. Eventually you'll reach Ripon's only ford, beside a wooden footbridge. Continue along the riverbank to the next footbridge – this is Alma Bridge. The pub next to it, now the Water Rat, was formerly The Alma. Both pub and bridge were named from the Crimean War Battle of the Alma in September 1854 in which two local regiments, the Green Howards and the Duke of Wellington's, both fought.

Cross the Alma footbridge and pass Alma House, now mostly apartments but once the residence of the master of the House of Correction. It later held a private museum owned by Mr Stubbs, whose 'leisure hours of SIXTY years have been spent in amassing the specimens and objects' that included 'a vast number of specimens in NATURAL HISTORY (especially in ornithology), numerous ANTIQUARIAN OBJECTS and RELICS, and a good collection of FOSSILS.' From the 1870s it was the premises of Skellfield School, which moved to Baldersby Park near Topcliffe in 1927. Novelist Naomi Jacob (*see* page 29), who lived round the corner in High St Agnesgate, was a pupil of Skellfield.

Near the corner of Low St Agnesgate and High St Agnesgate the building on the east side with an arched doorway and large windows is the part of the former Cathedral

The cathedral – the city of Ripon's spiritual heart – in the snow.

Primary School; it is now a private house. Turn left on to High St Agnesgate and then right though gateposts into the cathedral graveyard. Enter the cathedral by the south door into the south transept and stand under the central tower. You are now back in the spiritual heart of the city, a city whose secrets – ecclesiastical, civic, industrial and personal – are all worthy of investigation.

DID YOU KNOW?
The first recorded horse race exclusively for female riders took place on Ripon Common at a meeting in 1723, when Judith, wife of John Aislabie, the owner of Studley Royal and former Chancellor of the Exchequer, gave a silver teapot and canister, valued at a substantial £12, to the winner. Nine women took part, 'dress'd in drawers, waistcoats and jockey caps, their shapes transparent'. Unsurprisingly, there was 'a vast concourse' to watch them.

Acknowledgements

Ripon Re-Viewed

The Ripon Re-Viewed project brings to light an astonishing collection of photographic images that capture the changing face of the city of Ripon over the past century. Ripon Re-Viewed is a Ripon Civic Society project that has enjoyed financial support from the Heritage Lottery Fund and also been supported by North Yorkshire County Council. Everyone can see and enjoy online wonderful images from the collection through the Ripon Re-Viewed website www.riponreviewed.org. The website will continue to grow over the years ahead as more are added from the collection.